TOWER HAMLETS PUBLIC LIBRARY

C001

D0364372

Library Learning Information

Idea Store® Canary Wharf
Churchill Place
Canary Wharf
London E14 5RB

020 7364 4332
www.ideastore.co.uk

Created and managed
by Tower Hamlets Council

A NOVEL IN A YEAR

Novels by Louise Doughty

Stone Cradle

Fires in the Dark

Honey-Dew

Dance with Me

Crazy Paving

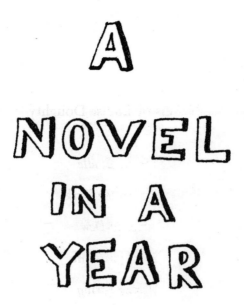

A NOVEL IN A YEAR

Louise Doughty

SIMON &
SCHUSTER

London · New York · Sydney · Toronto

LONDON BOROUGH
TOWER HAMLETS

C001533692	
HJ	11/10/2007
808.3	£11.99

First published in Great Britain by Simon & Schuster UK Ltd, 2007
A CBS COMPANY

Copyright © Louise Doughty, 2007

This book is copyright under the Berne Convention.
No reproduction without permission.
® and © 1997 Simon & Schuster Inc. All rights reserved.

The right of Louise Doughty to be identified as author of
this work has been asserted in accordance with sections 77 and 78
of the Copyright, Designs and Patents Act, 1988.

1 3 5 7 9 10 8 6 4 2

Simon & Schuster UK Ltd
Africa House
64–78 Kingsway
London WC2B 6AH

www.simonsays.co.uk

Simon & Schuster Australia
Sydney

A CIP catalogue record for this book
is available from the British Library

ISBN-10: 1-84737-070-5
ISBN-13: 978-1-84737-070-9

Typeset in Perpetua by M Rules
Printed and bound in Great Britain by
CPI Bath

For Ruby and Jacqui, chief allies

And with many thanks to Sam Leith

INTRODUCTION

In 2001, I presented a radio series for the BBC World Service called *Writers' Workshop*. Each week, I talked to two guests. We discussed their work and how they went about it, and at the end I asked them to give me their one, essential piece of advice for aspiring writers. Robert McKee talked about screenwriting and advised people to read his books on the subject. Martin Amis appeared on the episode about memoir and suggested, with great tact, that would-be memoirists should, perhaps, have a little think about whether their lives were really interesting to other people. A radio dramatist

talked movingly about a problem common to all writers whatever genre they work in, however famous or obscure they might be: the negative voices in one's head, the ones that whisper, this is rubbish. No one would want to read this. Who do you think you are?

My favourite piece of advice, however, came from the Australian novelist Elliot Perlman. What would he say to anyone who wanted to write a novel? He paused, then replied firmly, 'Think what you are prepared to sacrifice.'

Think what you are prepared to sacrifice. A year might be the least of it. When I decided I wanted to be a writer, one of the first people I told was the friendly, bearded man who ran my local second-hand bookshop. 'Not another book,' he groaned, gesturing around his premises, which overflowed with titles shelved and tumbling, piled high on the windowsills and on the wooden floor. 'The world is full of books. Why on earth do you want to add to them?'

'I want to make something beautiful that will give people pleasure,' I replied (I was young at the time).

'Plant a rose garden.'

Think what you are prepared to sacrifice. Writing a novel takes many, many hours, and those are hours you could spend planting roses, raising children, earning money – or even just having a nice life. What, in your life, is going to disappear, to allow you the time to write a book?

Throughout 2006, I wrote a column for the *Daily Telegraph* entitled 'Novel in a Year'. The title was gimmicky but the theory behind it completely serious. Can you write a novel

in a year? Well, it depends on how long it is, how much time you have available, how talented you are etc., etc. . . . In the feature that started the column, I was careful to explain that for many new writers three years was probably a more realistic estimate. I hoped that readers who decided to follow the column would enter into the year-long process in the spirit I intended, not seriously believing that if they followed my advice they would end up with a finished book but that they would get some idea of the processes involved and enough raw material that might one day be shapeable into a first draft. I also thought that if serious would-be novelists hadn't embarked on a book before and wanted to set themselves an aim, it was reasonable to suggest that they say to themselves, for this calendar year I will sacrifice x and y, and then see where I am. Many would not complete an entire manuscript in that time, but most would – I hoped – discover whether or not they might be able to do it at all, if they set aside enough time to try.

A year also struck me as a good amount of time to allow myself to talk through the many complexities of writing, to set exercises for readers to follow and to report back on the results. Aspects-of-literature columns had been done before but had been essentially literary criticism examining established, often great writers, not nuts-and-bolts guides for the relative novice. Whenever I teach on creative writing courses, I am always banging on about nuts and bolts – ways of structuring a plot, the difference between simile and metaphor, the usefulness of sucking

mints at your desk instead of stopping to make a sandwich. In contrast to many of my fellow novelists, my attitude to writing is pretty nerdy. I like the practical stuff, and I love talking about it. *So, why did you write that in the present tense . . .? You mean you never use flashbacks? Yes, what is it that is so satisfying about writing prologues and epilogues?*

Each week in the column, I took a different aspect of writing and then got readers to write examples of the issue or bit of technique in question and send them to me, so I could comment. The idea was that, week by week, the material would build towards a book. I also persuaded the *Telegraph* to set up a special section of their website, <u>www.telegraph.co.uk/novelinayear</u>, so that people could log on and post their writing on a message board and their fellow writers could also pass comment. Much as I would have enjoyed rabbiting on for a year, giving readers week after week of my little aperçus, that sort of advice was already widely available in a plethora of how-to books. What I was interested in was charting writers' progress over a year and encouraging them to stick with it for that period.

When I first suggested the idea of such a column to Sam Leith, Literary Editor of the *Telegraph*, we met for coffee to talk it through. I hadn't dealt with Sam before but he had been recommended to me by journalist friends as friendly and approachable. He was new in his job at the time, so I guessed, correctly, that he had not yet learned to be snotty to writers who came to him with proposals. (Still hasn't, bless him.)

'My only hesitation is,' he said, lighting a cigarette, 'can it really be true that nobody has done a column like this before?'

I had another concern. 'What if nobody writes in?' I said. 'Maybe I'll have to make it up, so I have something to write about the following week.'

'Have you got it all planned out?' he asked.

'Mmm . . .' I murmured, nodding, fingers firmly crossed beneath the table. The truth was, I had planned nothing beyond the first couple of columns. I had no idea what sort of response I would get.

The first exercise was very simple and designed to entice people in. It consisted of no more than completing the following sentence: 'The day after my eighth birthday my father told me . . .' (In coming up with the exercises, there was a tricky balance to strike. I wanted to encourage those who had never written a single word of fiction while keeping the column serious for the more experienced. The solution I came up with was to keep the exercises extremely simple for the first few weeks, then make them progressively more difficult.) When it appeared, I anxiously checked the 'Novel in a Year' website to see if anyone had responded, only to find that there was a problem with the link through from my feature to the message board. I eventually managed to get through myself by a roundabout route but thought that as it was so convoluted I couldn't expect any responses that weekend. It would have to wait until Monday when the technical glitch could be sorted out. Maybe no one

would respond for a week or two anyway. Maybe all the would-be writers out there were still nursing their New Year hangovers.

It was Sunday lunchtime when my partner wandered into the kitchen and said, 'Take a look at the message board.' No less than 162 writers had wriggled their way through the labyrinthine processes involved to post their 'The day after my eighth birthday . . .' sentences. To put this in perspective, under normal circumstances, a dozen letters to a columnist is considered a deluge.

By the end of the following day, we were in the high hundreds, and by the time I had to set the next exercise, 1808 people had responded and two bags of post had arrived. As I write this, in January 2007, there are 3174 responses on the 'Novel in a Year' message board to the first exercise alone.

After the initial flurry of interest, the responses, counting post and messages, settled down to anything between 300 and 1000 per exercise. As a rule, there were fewer responses when I set an exercise that was technically difficult or involved a high degree of invention, and many more when I encouraged writers to post something autobiographical. This was only to be expected. The letters I received made it clear that the writers responding were everything from octogenarians who had never written a word before to people who had already completed several full-length manuscripts. The overall impression I received was of a vast and varied writing community – and I was determined that the

complete newcomers should feel as welcome as the more experienced.

The lead-time of the *Telegraph*'s books section meant it wasn't possible to set an exercise every week. I wrote the column on a Monday for the following Saturday, so there was no time for letters from those who responded to the previous Saturday's column to reach me via the *Telegraph*. I set one each fortnight, with the alternate columns being opportunities for me to talk about aspects of writing that did not readily lend themselves to exercises, of which there were plenty. This confused some followers of the column, and occasionally confused me too, but it meant that my fifty-two columns included only twenty-six exercises, which considering the collective nervous breakdown the response level gave the *Telegraph*'s website department was possibly no bad thing. As well as moderating the site, they had to vet all contributions for libel or any other sort of illegality in the same way as if they were appearing in the newspaper. Stern 'terms and conditions' included the edict that they would not post anything 'obscene, defamatory or meaningless'. (Meaningless? I thought. These are novelists we are talking about here.)

The column was also syndicated in the *Sunday Independent* in Ireland, whose readers added to the *Telegraph*'s website – although when it came to the Italian version, in *Internazionale* magazine, a separate Italian website had to be set up and a translator hired to scour it for examples of writing comparable to the ones I

quoted in the English version. At one point, there was talk of syndicating the column in Canada, Australia and India as well, but negotiations stalled at the impracticality of managing the responses.

After the 'The day after my eighth birthday' exercise, I set a series of three further exercises encouraging people to record an autobiographical incident, again with beginners in mind but in the hope that the more experienced writers following the column might discover something to write about that they maybe hadn't considered before. The exercises then became progressively more complex but were still designed to generate material. At the end of April, I got writers to write a sentence beginning, 'My novel is about . . .', in the hope that they would begin to fix on one particular idea, but the 'idea-generating' exercises continued until the end of July. Only then did I get writers to sit down with their material, spread it all out before them and start to order it into something resembling a plot. After that, the talk about technique could begin.

The theory behind this was very simple and based closely on my own experience as a writer. It took me ten years to become a published novelist. There were many reasons why it took that long but chief among them was the fact that for most of that period I didn't really have anything to write about. I wrote two full-length novels and started several others before I finally wrote the one that became my first published book. Authors who followed my column would have spent seven months out of

twelve writing in quite a disorganised fashion, with no thought to how their raw material might be ordered, but I felt that was a necessary phase. Sculptors need a block of wood or some other material. Writers need material before they can begin crafting too. It is arguably misleading that we talk about getting 'an idea' for a novel. A novel contains hundreds of them – and that is not counting the hundreds more that have been tried out and discarded during the process of writing.

I can remember very clearly what it was like to be an unpublished writer, how hard it is and how horrible everyone can be and although I am now part of an industry that often appears armed and barricaded against aspirants, I still feel instinctively much more on the side of those attempting to scale the walls than those behind the ramparts. This may seem like no more than common decency but it is far from the case with many writers. Many published authors seem to have forgotten that they, too, were once unpublished. Many seem to have an attitude of blanket sneeriness to all those trying to climb the greasy pole behind them. This is partly self-protectiveness – all writers get bombarded with requests for help from friends, friends-of-friends and total strangers, on a regular basis – but it is also fundamental and unimpressive insecurity. We all like to believe we have 'made it' – stupid phrase – because of our innate and manifest talents. If others are helpable, then doesn't that imply that maybe, somewhere along the line, we have been helped too?

This probably explains the hostility I received from some writers when I told them about the column. 'Good lord,' said one, 'do we really need thousands of bloody *Telegraph* readers flooding the market with their unpublished manuscripts? It's tough enough as it is.'

'Isn't there some kind of novelists' Magic Circle that you'll get expelled from for revealing trade secrets?' asked one journalist friend.

'Don't you think it's a bit irresponsible, encouraging them?' said another, as if I was handing out crack cocaine.

What was obvious from the start was that very few of my readers needed encouraging to write. For most, the desire to write was so pressing, so all-consuming that no encouragement was necessary, but many did need help with technique. I don't believe there is any shame in this. As many others before me have pointed out, no one expects to tuck a cello between their knees and launch straight into Bach, but there are many who will throw their hands up in horror if you suggest that a talented writer has something to learn about prose style or plot construction. I do believe in innate talent and, of course, that can't be taught, but I also believe that a novel is put together with nuts and bolts and anyone who says it isn't either hasn't tried to do it or is lying because they don't like the idea of competition. I have met authors who claim they never think about technique, that they regard the process as some sort of mystic visitation whereby they sit at their desk and commune with their own inner genius. Considering the many blows that writers receive, I can

understand their need to flatter their vision of themselves but I do not regard it as particularly honest or honourable.

When it comes to nuts and bolts, there are a vast number of books or websites available to advise the tyro. Many of them contain interesting nuggets of information, although you sometimes have to wade through a fair amount of what is unhelpful or irrelevant to get to them. In the eighties, I was lucky enough to do the MA in creative writing at the University of East Anglia. The course's founder Malcolm Bradbury said to us at our first seminar, 'Ninety per cent of what you hear in this room is going to be completely useless to you, but the 10 per cent that is useful will be invaluable.' The same is probably true of any how-to-write book, including this – and it will probably be a different 10 per cent for different readers. What advice people need in the early stages of their writing depends so much on their level of skill and experience – not to mention personality type – that I wouldn't dream of being proscriptive. I make no larger claim than this: this book gives you an idea about how I do it, and here are a series of exercises that might help you have a go at it more or less my way. And before the brickbats start flying, I don't think that my own novels are perfect examples of the genre – far from it. I have published five to date and if you can be bothered to read them, you will find in each several clear examples of mistakes you should avoid. I see those very clearly myself now, and with subsequent books will avoid them too, preferring to make a whole different set of mistakes.

The columns were written in 800 word chunks, to be consumed weekly, and that is probably the most fruitful way to read the chapters in this book too. If you are lucky enough to be able to write full time then you might want to skim through it, cherry-picking what points you find useful and disregarding the rest. If, like most of us, you are combining writing with a hectic life schedule, then try to find a time each week that is yours and yours alone, Tuesday evenings or Sunday mornings, whenever you can manage. Try reading a chapter a week and using each as a jumping-off point for your own work. The point is not whatever may or may not come out of the exercises so much as what they inspire you to do on your own. If you do so week by week, then in theory you will be able to watch your material build up gradually over the course of a year. It was often frustrating to keep a particular point or piece of advice down to a set length, so nearly all of the columns have been edited and/or extended before they were included in the book, but they are still no more than an introduction to each topic area.

As I write this, in January 2007, the *Daily Telegraph* has agreed to keep the 'Novel in a Year' website live for as long as people are logging on and interested. This means that, in theory, you too can post the results of each exercise online, should you be so inclined – I will watch with interest to see what new stuff pops up. Throughout this book, I have quoted what people sent me in response to each exercise and if you find any of

them intriguing, you can go to the message board and do a keyword search to find the unedited version of what they wrote. If you have time to spare, take a wander through what you find on the message board – the sheer variety of what was sent in was one of the most interesting aspects of writing the column.

It is possible that by the time you read this, the message board will have been taken down or be dormant – or perhaps you are simply allergic to the Internet. If so, then take the examples I quote from the work I was sent as illustrations of the many ways in which the exercises can be interpreted.

Although the huge rise in formal creative writing courses and classes is a relatively recent phenomenon, there is nothing new in the belief that it is interesting to write about or discuss the various ways of making a novel. 'Sooner or later some such book as this had to be written,' said Basil Hogarth in *The Technique of Novel Writing*, published in 1934. Old Basil's book makes for interesting reading, not least because of the insouciance with which he refers to well-known contemporaries who have now sunk into relative obscurity. 'According to Frank Norris, famous writer of *The Octopus* . . .' That aside, much of his advice is the same practical stuff that any sensible writer would give a novice today – bar, perhaps, his insistence that 'the disputed succession' is a plot device that has been done to death and is therefore best avoided.

Even before Basil put his advice down on paper, writers had always banded together informally to read and

criticise each other's work, agonise together, support each other and quietly stab each other in the back. It is not normal to spend most of your life in a room on your own making up stories. I think we deserve all the help we can get.

It is tiresomely fashionable to slag off would-be novelists: in the press, at literary festivals, in the mean little conversations of the congenitally insecure. It is also fashionable to suggest that the huge growth of the creative writing industry is somehow indicative of our intellectual decline, as if the democratisation of artistic ambition is a terrible thing when so few are destined to be artistically talented enough to make a living out of it. What rubbish. At the age of forty, I started learning the piano. I am fully aware that I will never have a solo concert at the Barbican, but I have got hours of pleasure from plinky-plonking away in my own ham-fisted fashion, although I'm sure my neighbours would beg to differ (sometimes, I sing as well). Just as importantly, I listen to piano compositions now with an immeasurably enriched understanding of the skills of those who compose and perform them. Many would-be writers are also voracious and careful readers – they certainly should be if they aren't. Many are the ones who show up at festivals and pay their six quid on the door and queue to get their books signed or join reading groups or simply log on to Amazon when they've heard of something interesting. It infuriates me that some authors look down on those people. Without them, authors wouldn't exist. I

don't think it is indicative of *any* sort of decline that so many people want to write a novel. I think it is marvellous. Lots of other people want to appear on reality TV shows or make rock music or assassinate presidents. Isn't it wonderful that in an age where we are constantly assured that the printed word is dead and we all have attention spans of gnats that so many of us want to spend hour upon hour grappling with the complexities of writing fiction? How lovely that so many want to write something as old-fashioned, slow and arduous, as beautiful and instructive and magical as a novel.

If you are one of those people, reading this book will only help you a tiny amount. It is no more than an introduction to what is involved and it certainly provides no shortcuts to the sacrifices you will have to make, but I hope it will demonstrate that the process can be interesting and challenging in its own right, whatever the end result. Can you write a novel in a year? Can you write a novel at all? There's only one way to find out.

WEEK 1

Some years ago, I was sitting in a café with a writer friend. He was a comedy-sketch writer whose first full-length work for television was in production. I was a part-time secretary who had published a few book reviews, had a play accepted by BBC radio and was working on my first novel. We were both living in cheap rented rooms, earning a living doing bits of this and that and full of hopes and ambitions for our professional futures.

My friend had just come from giving a talk to a group of sixth-formers. One of them had asked, 'Why did you become a writer?'

'You know what?' he said to me, stirring his cappuccino. 'I gave them some flannel about the joy of language and the process of creativity, but actually, the real reason I became a writer was so that I could move to London and sit in cafés with other writers and talk about why I became a writer.'

I knew exactly what he meant. For those of us, like me and him, who come from decidedly non-literary backgrounds, there is something wonderful about Being a Writer – all the shallow stuff we are supposed to despise: the café talk, the book launches, the scanning of literary pages feeling guiltily gratified when a friend gets a bad review. Forget for a moment the loneliness and fear, the paranoia and financial insecurity, Being a Writer is great fun.

But there is a catch. You have to write. This is something that would-be writers sometimes seem not to have grasped. Like many novelists, I often give talks at festivals or teach on residential writing courses, and the commonest question is, 'How did you get your first novel published?' This is a perfectly valid question but I sometimes feel the motivation behind it is suspect. *What was your trick?* is what they mean. *Tell me your trick, because when I know it, I will be published too.* It would sound arrogant to reply, 'I was published because I wrote a good book', but it would be more honest and perhaps disabuse aspiring writers of the notion that being published is some kind of holy mystery, or only happens if you have 'contacts'. For the record, I had absolutely none, even

after I had done the MA in creative writing at the University of East Anglia, a course widely and mythically believed to offer a passport to publication. I got an agent because I won a runner-up prize in a short-story competition that was open to all unpublished writers. I got a publisher because I eventually wrote a novel good enough for the agent to sell. If you are a would-be novelist, it may seem baffling to you that so many bad novels get published but it doesn't change the very unbaffling fact that if you want to publish a novel yourself, you have to write a good one.

Very few people write a good novel on their first attempt. I certainly didn't. My first published novel was actually the third one I had finished, and that's not counting the numerous false starts, often thousands of words long, novels that came to nothing after months of work. If you, too, have had those false starts, it is important not to get disheartened by them and to remember that they are a necessary part of the process. I always chortle when I read an earnest biographer writing of Mr or Mrs Great Dead Author, 'If only he/she had not destroyed those early manuscripts, what treasures must have lain therein!' Poppycock. Mr or Mrs Great Dead Author burned the early stuff *because it was rubbish*.

The work you will produce if you follow the remaining chapters of this book may well be one of those false starts – if you don't have a good idea for a book, then there is nothing I or anyone else can do to plant one in your head. If you do the exercises I set, what you will end

up with will not be a novel, it won't even be the first draft of a novel, it will be a body of work, the raw material, which you may one day be able to shape and work on until it becomes a book.

How long does it take to write a novel? Well, it depends. My first novel, *Crazy Paving*, was written while I was a part-time secretary and took me eighteen months. That's quite quick, actually, but I was young and single and had no domestic commitments. By the time it came to writing my second, I was theatre critic for a Sunday newspaper, which meant I had all day to write before leaving the house, owl-like, to go to the theatre in the evenings: as day jobs go, it was a corker. *Dance with Me* was written in seven months. My third novel was sold on the strength of a one-page proposal when I was pregnant with my first child. I promised my publisher the book would be delivered before the baby but I was lying through my teeth. Baby arrived when I was one chapter in. My partner worked full-time and we had no childcare but I still had to finish the book as we had spent the advance on buying a flat to have the baby in. *Honey-Dew* was written in eight months while I was half-dead with exhaustion. There's a reason why it's my shortest book.

Then came my fourth, *Fires in the Dark*, which was a huge departure for me. My first three had all been contemporary and peopled by women characters roughly the same age as myself. The events in them weren't remotely autobiographical – *Honey-Dew* is about a girl who murders her parents – but it's fair to say that in

terms of their landscape, language and scope, they were within my own experience. *Fires in the Dark* is set in Central Europe over three decades of the twentieth century. It is about a boy who is from a tribe of nomadic Kalderash Roma. Born in a barn in rural Bohemia, he grows up during the Great Depression and the rise of Nazism, is interned in a camp, and escapes to take part in the Prague Uprising of May 1945. It was three times the length of *Honey-Dew* and took me four and a half years to write. My fifth, *Stone Cradle*, was also a long, historical novel but was written in a quarter of the time because I had learned that you don't need to know absolutely everything about an historical period to write historical fiction.

So, in other words, how long is a piece of string? Your novel will take you as long as it takes you – but I'm going to stick my neck out and say that if you haven't written a book before and are really serious about it and have the normal encumberments that many of us have, a job or a family or – heaven forbid – both, then you are looking at around three years from start to finish. This book can guide you through Year One, which is when you will get started, gather material, make notes, plan, write some scenes. In Year Two, you will despair, put it aside, come back to it, think you are wasting your time and then realise you want to go on anyway. Year Three is when the real work of rewriting and honing will begin.

Still want to do it? Good, we'll get started in a minute.

Before we do, let's establish a few things that this book does not do. It does not, bar a few general pointers at the end, give advice on how to get into print. When I was writing my newspaper column, I was absolutely firm that any letters or emails asking me how to get an agent or publisher would be made into a ceremonial pyre in my back garden and torched. This may have been cruel but I stand by it. Any aspiring author should be spending only 1 per cent of their time thinking about how to get an agent and the other 99 per cent on devising an engaging plot, creating convincing characters and writing clear and beautiful prose. Too many would-be writers have that 1 per cent and 99 per cent the wrong way round. Getting published may seem impossible, and often is, but if you haven't written a good book yet then quite frankly it's the least of your problems. Your only concern right now should be to write. Write your book, write it well, then rewrite it even better.

It's at this point, I suspect, that one or two of you might be getting a little sneery, particularly if you've already written a novel that hasn't been published, or are a veteran of a creative writing evening class. Engaging plot? Convincing characters? Clear prose? *Pah!* That's for beginners.

I used to teach on one of those evening classes. My least talented students were invariably the ones who came with a curled lip, convinced that they were far cleverer than anyone else in the group and that the only

reason they weren't a published writer like me was because of some vast conspiracy against them, of which I was naturally a part. On the one hand, they wanted to touch the hem of my garment, as if being published was a virus they would catch if they rubbed up against me long and irritatingly enough. On the other hand, they were convinced they had nothing to learn about actual writing and despised themselves and their fellow students for even being there. Here is this week's aperçu: we all have something to learn. Even Ian McEwan or Margaret Atwood or Toni Morrison still have something to learn, and the reason they are great writers is because they know it and work bloody hard on each and every book.

Nobody can teach talent, and if you read this book you will be no more or less talented at the end of it than when you started. Nuts and bolts can be taught, though, and there is more nuts and bolts to novel-writing than many novelists care to admit. Take plotting and structure, for instance, one of my favourite topics. 'All stories have a beginning, a middle and an end,' said Jean-Luc Godard, 'just not necessarily in that order.' It's cute, but it isn't true. Even books that appear to be completely artless and plotless have a structure of sorts by reason of the fact that they are novels and if they didn't have any structure they would be thoughts. 'Every time I am about to start a novel,' says the highly accomplished and experienced Susan Hill, 'I look at it, and it is like a mountain and I say to myself, oh no, this time you have

gone too far.' If you simply sit back and think about the enormity of writing a book, let's say of 80,000 words, it will seem a vast and unconquerable task, impossibly daunting. The way to make it less daunting is to break it down into its constituent parts, to do it bit by bit. Over the chapters that follow, different aspects of technique are divided up into bite-sized chunks, the better to aid digestion. Many of these topics overlap, of course, and doing an exercise on dialogue, for instance, may well send you shooting off into writing a passage of description. That's okay. At this stage, your writing does not have to be perfectly ordered, there would be something a bit peculiar if it was. The main thing is to get as many words on the page as possible. You can always sort out the mess later.

'The art of writing,' Kingsley Amis said, 'is the art of applying the seat of one's trousers to the seat of one's chair.' So start now. Take up a notebook and pen . . .

EXERCISE 1

. . . and write one sentence, beginning with the words, 'The day after my eighth birthday, my father told me . . .' Write more than a sentence if you like but just one sentence is fine.

It may be that thinking about how you finish that sentence gives you an idea for another, and another, and another . . . but it doesn't matter if it doesn't. It may be that while you are doing this first-sentence exercise, an idea pops into your head for a first sentence that is entirely your own but, again, it doesn't matter if it doesn't. Just complete the one I've suggested if that is all you feel like for now.

While you are doing this exercise, you may well find a small, mocking voice whispering in your ear. It will be saying things like, 'Don't be stupid, you can't write a novel,' or, maybe, 'This is stupid, I'm too clever for this.' Both thoughts are equally destructive and both must be ignored. Everyone has to start somewhere. Laurence Sterne, Emily Brontë, Nadine Gordimer all started somewhere. Every novel in the history of literature began with one sentence, so begin.

WEEK 2

You are going to start writing a novel. What do you think might be the most useful thing you can do to prepare? Sharpen your pencils, perhaps? Clear the bank statements from your desk or the crumbs from the kitchen table in order to have a flat surface? Prune the privet hedge so it won't annoy you when you look up and glimpse it through the window?

There are many ways in which one can prepare to write a novel but there is one thing you can do, and continue doing, which will really help. You must read.

I have lost count of the number of times I have been

at events with other novelists and heard them say, 'Well, I don't actually read other writers when I am working on a book myself.' To not read when you are writing seems as odd as refusing to listen to any French when you are trying to learn it. Do athletes not watch anyone else running while they are training? Do surgeons say, 'I think it's best to ignore any new medical developments while I'm practising myself'?

Writers who don't read would probably defend themselves by claiming they don't want to be influenced by others but that strikes me as an equally odd position. Bad writing can be an incredibly positive influence if you learn to analyse *why* it is bad and resolve not to do the same. Good writing can also be helpful, although in many ways less so. When a sentence is bad, it is often obvious why. A good sentence is often good not just because of the mere assemblage of words on the page but because of the context in which it is set, the way in which the novelist has prepared the ground for this wonderful line or observation.

Most helpful of all, I think, is a novel where the writing is good and bad, which luckily for you includes the vast majority of contemporary fiction. And here we come across a word you should take note of: contemporary. I don't wish to discourage you from reading the classics – unless it's Henry James, in which case I would discourage you from even giving him room on the shelves in your toilet. (Oxfam likes unwanted books, I believe.) But if, as is almost certainly the case, your time

is precious and you are trying to focus intently on your own work, you will get more practical help from reading Hilary Mantel or Graham Swift than you will from George Eliot or Leo Tolstoy. All writers are a product of their era, however timeless the themes of their writing or the excellence of their prose. If all you read is Dostoevsky, then however much you enjoy his work as a reader, as a writer you will simply get depressed because you will never be Dostoevsky. But if Dostoevsky was writing today, then he wouldn't be Dostoevsky either. 'On a very hot evening at the beginning of July a young man left his little room at the top of a house in Carpenter Lane, went out into the street, and, as though unable to make up his mind, walked slowly in the direction of Kokushkin Bridge.' Read the first line of *Crime and Punishment* and you know instantly that you are in a nineteenth-century novel. The length of the sentence is a clue but the real giveaway is the phrase, 'as though unable to make up his mind'. The omniscient narrator who says, uncertainly, 'as though', only appears nowadays in the pages of pastiche.

Read. Read as if your life depended on it because your life as a novelist does. Read for sheer enjoyment — what sort of books you enjoy reading provides a pretty strong clue as to what sort of book you should be writing. But also learn to read critically. If something that a particular writer is doing rings your bell or gets your goat — why? As a reader, you may favour a certain style or genre; as a critic, you should be an omnivore. Go into a

library or a bookshop, and pick up half a dozen contemporary novels at random. Would the first page make you want to read on? If not, why not? Read and keep reading. It isn't just a matter of learning from other people's mistakes, it's a matter of learning how novelists think, so you can think like one too. Steep yourself in the language of fiction in exactly the same way as you would read as much French as possible if you were trying to learn it. When you have learned to analyse and criticise other writers' strengths and weaknesses, you will be well on your way to learning how to analyse and criticise your own.

WEEK 3

'The day after my eighth birthday, my father told me to take the fish finger out of the soup, wrap it in a tea towel and take it to Granny.'

Is that possible? Wouldn't the fish finger dissolve? Depends how long it was in the soup, I suppose. How is Granny going to eat it? Unwrap it first, or suck it through the tea towel?

See, I'm hooked. The author of this reply to the first-sentence exercise certainly had an original voice. One sentence was too little to tell me whether 'Bridin' was a writer or not, but I would definitely read on.

It's a fine line, though, humour. 'The day after my eighth birthday, my father told me I was now old enough and ugly enough to realise that I was asking for trouble if I set light to my brother's trousers while he was still in them.' That was from AJS, a regular contributor to the message board throughout the year, who clearly wrote in the same spirit as another, called Glenn: 'The day after my eighth birthday, my father told me that I shouldn't strap the dog to my new skateboard.' Both of those sentences could have lead on to perfectly serious stories, but I suspect they were simply having a bit of fun. I also suspect that one Paul Marshall probably had no intention of continuing the story that began, 'The day after my eighth birthday, my father told me to put down the knife and step away from the hamster.'

I understood the urge to take the mickey out of the first exercise I set (truly, I did). Faced with the realisation of how many others were sending work in, some followers of the column were keen to stand out from the crowd. Amusing as they were, the jokey one-liners I was often sent did make me think of a fat person who deals with their obesity by making jokes about how heavy they are. However much you admire their coping strategy, you can't help feeling they would be better off if they took their problem seriously and went on a diet. I am not against humour in fiction – far from it, there is quite enough po-faced stuff around as it is. But even comic writers have to take themselves and their work seriously. It is always easier to take the mickey out of yourself and

your writing ambitions than it is to knuckle down and risk ridicule from others.

My personal favourites from the first-sentence exercise were the ones that were both simple and serious, and where the implied context went beyond the character of the narrator. A writer called Joanna Lane sent me this on a postcard: 'The day after my eighth birthday, my father told me I couldn't play with Ahmad any more.' Even more sinister came this from M. Shaw: 'The day after my eighth birthday, my father told me, "Jews do not go on picnics."' I instantly located that sentence in 1930s Germany, with all the sense of foreboding that involved. I might have been quite wrong, of course, but, either way, what both of these sentences did was take the reader immediately into a universe where what was at stake for the main character would clearly be indicative of what was at stake for the wider society in which they lived. In other words, they opened up a world before us. The very best opening lines from novels draw us in because they are like portals to a whole universe.

Like this, from Libby Pearson: 'The day after my eighth birthday, my father told me he had found me a husband.' Where is that story set? When is it set? How is this young girl going to respond to the news? Libby Pearson's sentence is made up of deceptively simple words that create an instant picture of a complex situation. Keeping your first sentence simple is a very, very good idea. Another responder, Nick Green, kept it simple while simultaneously tackling the question of why

a child should remember something said the day *after* a birthday: 'The day after my eighth birthday, my father told me why it had slipped his mind.'

These were a tiny percentage of the intriguing and well-written example sentences I was sent at the beginning of the year. Yes, there were plenty of dull ones too – given the sheer volume of replies it would have been strange if there hadn't been – but I gave up printing out the good ones from the website very quickly because I realised I would run out of paper. Gathered together, they would have made a book of their own.

EXERCISE 2

The next exercise also involves writing a sentence. Write down, in plain English, clearly and concisely, why you want to write a novel – not why you want to be a writer, but why, specifically, a novelist. Avoid the temptation to be clever or funny; at this stage that would be evasive. Sit somewhere quietly for a minute and think about it. Be simple and honest with yourself. 'I want to write a novel because . . .'

WEEK 4

I once took part in a BBC radio discussion where the subject matter was, broadly speaking, 'Is writing a novel harder than writing anything else?' As it was Radio 3, they put it a bit more elegantly but that was the gist. My fellow panellists were the author of a best-selling memoir, a political writer and the editor of a literary magazine. Chummily, they all agreed: fiction? Psshaw! Book reviews were jolly tricky. Poems were prettier. And non-fiction had *soooo* much more gravitas. As the token novelist on the panel, it was left to me to splutter into my microphone, but, but . . . think of the work

involved; the imagination, the structuring, the crafting of the prose. No, no, they chorused. You just make it up!

There are many points to be made here, but the most important, I suppose, is that a great novel can encapsulate all other sorts of writing; as beautiful as a poem, as full of emotional truths as any memoir and with all the drama of the most gripping play. That is why, for me, novels are the ultimate written art form, the Himalayas of literature. I have great respect for other forms of writing too – but even highly accomplished poets and playwrights have admitted to me that the sheer amount of words you need for a novel is off-putting for them. Novels are so . . . well, *long*. I really do believe that writing one is harder than writing anything else.

Perhaps that's why we do it. Sheer bloody-mindedness. We could all live perfectly useful lives if we didn't write novels. Think of the hours we could spend with our families or hoovering the stairs – I'd have awfully clean stairs if I didn't write books. The truth is that many of us write novels for the same reason that George Mallory gave for climbing Everest, 'Because it's there.' There is nothing more satisfying than doing the hardest thing, even though you may risk all in the attempt. Few people freeze to death writing their books but they do ruin marriages, neglect their friends and sacrifice perfectly decent careers. They do it because the challenge is there and because the feeling of wanting to have achieved it overwhelms the many sound reasons for not doing it.

This is why, as far as some novelists go, there is a law

of diminishing returns. How many times have you read a new novel by a very famous author, been horribly disappointed and thought, this would never have been published if it wasn't by so-and-so? It's true, it wouldn't. It's disastrous for anyone's art when they stop being hungry. Be heartened, then, by the indisputable fact that you have one advantage over established writers. Yes, they have experience, the satisfaction of knowing their work will probably be published and (maybe) provide an income. But there is one thing you have that they don't, and it is not to be sniffed at. It is the wonderful passion, ambition and innocence that comes when you first begin to write, the belief that you really can climb Everest.

There will come a time when that ambition and innocence must be channelled into technique but before then exploit both wholeheartedly. Later in this book, we will move on to nuts and bolts, to plotting and structure, to description and dialogue, but, in the meantime, there is nothing wrong with enjoying the mere fact of writing, without regard to how it will have to be ordered and crafted. Naive enthusiasm is a huge asset in the early stages when the most important thing is to write.

The formal exercises in this book are set in alternate chapters, but if you are reading it week by week then use the other weeks to do something very important: write freely, enthusiastically, anything you like. Scribble down odd ideas on bits of paper. Begin short stories that may go nowhere. Write up an autobiographical incident that may or may not be worth fictionalising. It may be that an

exercise set the previous week inspires you to continue in a particular vein, but if it doesn't, then use your weekly time to free associate. The most important thing is to not censor yourself at this stage. Go out and buy a notebook, if you haven't already, and just write anything. Make lists of words you like, for no good reason other than you like the sound of them. Browse a dictionary. Jot down descriptions of a tree outside your window or a phrase overheard on a bus. Don't think about why you are doing it or whether it's any good or will ever see the light of day. The point is simply to make use of the time you have set aside for your writing in a way that is writing-related. (I've already talked about the importance of reading – it's a good idea to always have some reading to hand, so that if you are ever truly stuck and don't want to write a single word, you can pick up a novel you are interested in and read that instead. Time spent reading is never wasted.)

Later in the year, you will be gathering up all this loose material from this early phase, discarding most of it and beginning the infinitely complex process of turning the gems that remain into a book, but don't think about that for now. Write anything. Write a description of the sound your boiler makes if you feel like it. Why? Because you can.

WEEK 5

When I asked readers of my newspaper column why they wanted to write a novel, the responses that flooded in were many and various. A few admitted to craving fame and riches, but not as many as I had expected. A cheering number said it was because they loved reading and liked the idea of being able to give someone else the same degree of pleasure. Some said that, on reflection, writing a whole book was clearly an awful lot of work but they were going to persist with the exercises anyway, for the fun of it. I was impressed by the straightforwardness of an Anthony Wong: 'I seriously

asked myself why I wanted to write a novel and realised I don't really want to after all.' Top marks for honesty.

Two motivations cropped up again and again: the sheer joy of creating a world of characters that is all your own; and the challenge of crafting language to show a picture of those characters to other people. 'I could no more abandon the characters arguing, loving and living inside my head than I could ignore my own children,' said an author calling him or herself 'Cherub'. 'I am fascinated by people,' said an Ann. 'I can waste hours just people-watching. Who are they? What are they doing/thinking? Where are they going, both in life and in fact?' I can remember feeling like that as I commuted to work in my office-job days. I can remember staring out of the bus window and watching an elderly woman struggling along the street in the rain and feeling desperate to know her story. How could I make that story come alive in words?

An endless fascination for others is a prerequisite to being a novelist – despite the common view of novelists as egocentric and self-absorbed. The self-absorption comes when you are at your desk writing. The rest of the time, you need to be pathologically curious. We all live in worlds peopled by characters that play a small or large part in our narrative while we play a small or large part in theirs, each of us intersecting in a giant Venn diagram. We know only a tiny part of other people's stories, most of the time. Being a novelist is a great excuse to go in search of the rest. 'Writing is my excuse to go and find

out about things,' said Martha Gellhorn. That was part of what made her a good journalist, but many fiction writers would benefit immeasurably from the same attitude. In the service of various bits of research for my novels, I have travelled across Europe, interviewed policemen and psychologists, skulked around graveyards and blagged a ride in an emergency helicopter from the rooftop of a hospital in London. I hated the helicopter ride – I've never been so scared in all my life – but a character in my second novel was a helicopter pilot and he needed developing, so up I went, clinging to my seat like grim death and hyperventilating all the way. Whether or not such an experience helped me write that character better, I shall never know. It certainly gave me an insight into just how different he had to be from me.

What do you want to know about? What interests you? Ideas for novels often come out of an author's abiding obsessions but simple curiosity will do. At a writers' get-together one evening, I found myself chatting to the novelist Deborah Moggach, whose wide-ranging novels are brilliant examples of a writer who can turn her hand to anything because she is so full of bounce and energy and *interested*.

'What have you been up to today?' I asked innocuously.

'Oh, I went to court,' she said. It turned out she had spent the day sitting in the observers' gallery at the trial of the gang of armed robbers who had attempted to steal a load of diamonds from the Dome by driving heavy

vehicles into it at speed, only to find a large number of our finest law-enforcement officers lying in wait.

'Are you writing about it?' I asked.

'Dunno,' she said, 'I just thought it was such an interesting story.'

I love the idea of Deborah, a seriously glamorous lady, sitting alone in the gallery, with the wives and girl-friends of the armed robbers all glancing at her askance and whispering, 'Who the hell is *that*?' Now there's a story.

There is nothing to stop you from sitting in on a criminal trial, or reading a book about the history of the Great Wall of China, or asking the local donkey sanctuary if you can volunteer for a day. If you're interested in armed robbers or ancient monuments or donkeys, why not? Being interested in things is a great impulse and tremendous fuel for your writing.

A converse motive was mentioned by a website contributor called 'Pip'. Few established writers will admit to this one but it is an abiding factor for many. 'Writing a novel is a pastime which lets me put things happening in my own life into perspective,' wrote Pip. 'It's almost like talking to a psychiatrist without the expensive bills.' I agree with all of that apart from the 'almost'. Frequently, what lies behind a novel is a burning desire to lay something to rest, a feeling that an event or a sentiment can be made sense of if it can be written about. 'It's not that I want to write a novel,' said a Nicola. 'It's more that the novel wants me to write it. And it's hounding me, even

in my sleep.' That may have sounded nutty to non-writers but I knew exactly what she meant. We are back to the most pressing motivation of all: the feeling that one can't not do it.

What was clear from the responses I got to the why-write-a-novel question was that many people reading the column already had an idea for a book taking shape and that is no doubt true of some of you reading this book as well. The next three exercises are aimed at those starting from scratch, but I would urge the more experienced of you to do them anyway. If you are a bit stuck in the early stages of a novel, or even stalled mid-book and not sure where it is going, the solution is often to allow yourself to go off on a tangent. The exercises may seem irrelevant to what you are working on, but the results may turn out to be something you can add in, or simply give you an idea for something completely different that could happen to a pre-existing character. One of the great joys of writing a full-length book is that in the course of several hundred pages, there is room for all sorts of hidden depths or surprise elements that can be fed into your main story. Even if you are working determinedly on an idea that you feel is fully formed, give these early exercises a go. You might be surprised what comes up.

EXERCISE 3

Think about a time in your life when you had an accident, a physical accident, and write a simple and straightforward account of it. Just write what happened, without embellishment or analysis, as if you were telling someone the anecdote over a pint or a cup of tea. For some of you, this might be something dramatic like a car crash – for others it might be as simple as stubbing a toe or breaking a vase. It may have been an event of lasting consequence or just one of those things that happens. You don't have to write it in beautiful prose, in fact it's important not to worry about style at all at this stage, but try to get in as many of the important details as possible, what led up to it and what the consequences were.

Whenever I do this exercise on creative writing courses, the most extraordinary stories come out – stories that would make your hair curl. You may be one of the few to whom nothing physically dramatic has happened, but if you think about it for a bit, I suspect you will remember a relatively minor incident that nonetheless had meaning and consequence. If you have truly lead an accident-free life, then, at a pinch, you can describe

an accident you have witnessed, preferably in real life but even on the telly will do. I suspect most of you won't have to resort to that, though. Our ordinary lives are full of incident, when we stop to think about it. It is those incidents I want you to start mining now.

WEEK 6

'What would happen if one woman told the truth about her life?' asked the poet Muriel Rukeyser, then answered her own question. 'The world would split open.' I would go further. I think the world would split open if any individual, male or female, white or black, young or old, told the truth to themselves and those around them. We are all packed tight as atoms – the fall-out would be vast.

How many secrets do you have? Have you ever done a rough tally? Skeletons in your closet? I bet you've got enough to fill an underground car park. All of us are full

49

of stories and many of those stories remain hidden for good reasons. Your husband would be horrified if you told him about the baby you had at fourteen but gave up for adoption. Your old friend George would never forgive you if you said the real reason he isn't invited at Christmas any more is because your son can't stand him. Intersecting webs of secrets, big and little, are how we all construct our lives. Spend a day being completely honest with everyone around you, and you'll soon find out why.

The stories inside us are like gold dust, but how do we turn those stories into credible fiction without it reading like bad memoir writing? 'The novel I'm working on at the moment is really thinly veiled auto-biography,' a writer friend admitted to me once. 'I'm just having difficulty with the thin veil.' If you're new to writing, you might be finding it hard to draw the line between what has become known as 'life writing' and what we might broadly refer to as 'creative writing'. An exercise in personal exorcism isn't necessarily art, although – confusingly – it sometimes can be. The solution, I think, is to accept that excavating our own secrets and stories is simply the starting point. It is mining the ore that must then be smelted to make iron. But if you write auto-biographical stories in the full knowledge that you will probably have to rewrite them thoroughly, then there is no harm in using your own life to begin with. The veil, thin or thick, can come later.

That is why in the last chapter, I asked you to write

about an accident that had actually occurred to you. In the chapters to come, we will be doing more exercises like that, which make you stop and think about just some of the many, many stories you have locked inside yourself. Then we will move on to how you can take those stories and turn them into fiction. I said that to be a novelist you needed to be pathologically curious about other people, so it may seem contradictory that I then asked you to write a story about yourselves, but being truly, deeply curious about yourself is a good start to learning about other people as well. It goes back to what I was saying about naive enthusiasm. Yes, there will come a time when your enthusiasm must be tamed into technique. Similarly, there will come a time when you must learn how to take your own stories and reinvent them, but before you can do that, enjoy the fact that your own life is a starting point – no more than that, perhaps, but you've got to have a starting point before you can go anywhere else.

Those of you who have now done the accident exercise will, I hope, continue to write down similar events in your notebook – anything that seems quirky or individual or strange. What I am hoping is that over the next few chapters, you will all start to build up a body of material – anecdotes, notes, stories. The essential point is that you do not, at this stage, give any particular thought to whether or not any of it might turn into an idea or be included in a novel. One of the best descriptions of the writing process I have come across is from

the American writer Judy Delton: 'Writing is an active occupation, not a passive one . . . waiting for inspiration is like waiting for friends. If you sit around the house and don't go out and meet them, they will never come. You have to make things happen.' If you don't already have an idea for a novel, then these exercises will act as warm-ups, a jog round the block before the marathon – and ideas may well come through them. If you do have an idea, then writing about something completely discon-nected from it may prove equally fruitful. Take your accident incident and try giving it to one of your pre-existing characters. In what way does it change them, give them depth? Everyone reading this book will have been involved in or witnessed an accident of some sort at some stage in their life, however minor. Equally, if you have a cast of characters in a novel, and you are trying to make them real and give them depth, why not wonder what accidents they may have been involved in or wit-nessed? Such incidents may be dramatic and defining – and if they are, they may well feed into or even become the main plot of your book – but even something minor that you don't include can help you flesh out your char-acters, can help you feel that they are real people full of stories. You should always know more about your char-acters than you can possibly include in your book.

WEEK 7

When I asked readers to write about an accident from their real lives, the results were predictably fascinating and dramatic. David W. Hearsey DFC sent me an account of near-death over Leipzig in 1944. Robin de Grey wrote from Portugal to tell me of the time he almost crash-landed a light aircraft into Luton Airport. I learned that E. J. Ormerod was extremely lucky to have both arms after an incident that occurred while he was making copper tubing in a factory and that Linda Langton would always blame herself for the pear-shaped scar on her brother's right hand.

Not all the stories I was sent resulted in lasting injury, although there was a huge amount of car-crash tales that made me wince. Such stories were the most dramatic, but the relatively insignificant incidents often had some fascinating details – exactly the sort of detail that a good novelist would use. Jenny was sitting on a train that had just begun to move when she spotted a friend on the platform. One foolish leap later and she was lying dazed and bleeding on the concrete. As her friend ran for help, 'I noticed two old people on their balcony looking at me through their binoculars.' Liz wrote about falling down outside a café in the Peak District only to find that when someone went back inside and asked to use their phone to call an ambulance, they were refused because Liz hadn't fallen down on their premises.

The reaction, or non-reaction, of witnesses to an accident was a common theme, as was a lasting feeling of humiliation. Most heartbreaking of all was the number of people who felt that something they were responsible for as a child revealed a greater truth that has haunted them ever since. An author calling herself Izzy wrote a moving account of accidentally hugging her terminally ill mother too hard, prompting an outburst of rage from the mother that was more about her fear of dying than her child's embrace.

It is these lasting consequences that make accidents such rich material for use in fiction. Even if the accident that has happened to you feels comparably insignificant, there is no reason why you cannot use your imagination

and embellish it. The real version is no more than raw material, after all. An author called Audrey sent me a story about an accident that happened to her on Bonfire Night, 1950. 'Almost ready to go home, I stood at the back of the crowd and watched as someone placed five rockets into five milk bottles on a wooden base . . .' One of the bottles fell over as the firework exploded and she was hit in the face. Progressively traumatic medical procedures followed, culminating in total blindness in one eye. For most of her account, Audrey seems remarkably philosophical about the whole thing, until the last line. 'It was an accident, just one of those things. But I would give anything to turn back the clock and go home earlier.' If Audrey was inclined to fictionalise this incident then it is easy to see where the layers could be added. What if her mother had wanted to go home but her father had suggested they stay? How would that affect their marriage and the future of their family? What if it was a school friend or brother who put the milk bottles out carelessly? What if, in the darkness and confusion, no one realised how serious her injury was, resulting in needless complications? How would a fictional character to whom that had happened react when she had children of her own who wanted to go to a firework party? In a novel that was ostensibly about the main character's adult life, an interposing series of flashbacks could gradually reveal more about the incident and the reader would come to realise, through a series of revelations, the impact it has had on that individual's life.

Not all accidents will make a novel – some will only make a short story or no more than a minor incident within a larger story, but incident and event of any sort is the stuff of fiction, the bare bones that you can flesh out later.

EXERCISE 4

I want you to write about a time when you got lost. Again, it could be a small incident – getting lost in a shop or on a beach – or it might be something dramatic, deserted and bewildered in the forests of Peru. The difference between this and the accident exercise is that I want you to feel free to interpret it a bit more broadly: lost in a metaphorical sense as well – lost in a love affair, lost in a family that doesn't understand you. If it feels right to fictionalise the story, then go ahead, but a straightforward anecdotal account is also fine. Bear in mind that there are no right or wrong answers to any of these exercises. The important thing is to write them down, to use language to get the incident across, in whatever form you choose.

WEEK 8

Now you have started writing, there is one very obvious issue that you will have come slap bang up against that has nothing to do with inspiration or technique: finding the time to write. I can encourage you to get ideas or tell you why I think it's a mistake to use too many adverbs, but there is nothing I can do to carve out the time in your life that will allow you to write a book. All I can do is describe the way I manage it, which is to view it like this. There are certain time-consuming tasks that I can't avoid: raising my children, earning a living, eating and sleeping. These are non-negotiable. But there

are other time-consuming activities that most people take for granted in their lives that fall firmly into the non-essential category: taking exercise, watching television, cleaning the house. I would love to sort out the weed-covered rectangle of space that we in our family refer to euphemistically as 'the garden'. Every time I look out of the kitchen window, I wince at the unpruned shrubbery, the collapsing fence and the so-called lawn where I may as well erect a sign saying, 'Local Cats Poo Here'. But the truth is, in the X number of hours it would take me to clear that depressing junkyard, I could probably write something that would earn enough money to pay some-one else to do it. That I do neither is not the issue here. The point I am making is that time spent on any non-essential activity is time you could, and probably should, be spending on writing. Do you want to lie on your deathbed saying, 'I wish I had written a novel' or 'I really should have taken the curtains to the dry cleaner's more often'?

There is, however, no logic to the issue of finding time to work on a novel. The least productive periods of my writing life were the stretches when I was on the dole or a student, single and childless, with acres of time on my hands. There is something about having washes of time that seems to militate against productivity – guilt, perhaps, or the feeling that if one has lots of time to write then somehow it has to be really good and if it isn't then what's the point? If you are retired or have somehow managed to take a period off work to write, you may

well be finding it extremely hard to knuckle down for similar reasons. Those of us with much tighter time schedules may gnash our teeth at you, but I'm not sure you have it any easier, in fact.

The solution for both groups is actually the same. It is a question of corralling time, of marking out your own special place for writing in your weekly schedule and making it sacrosanct. Fay Weldon has said that when her children were small, she would get up at four or five in the morning and crouch down in front of the gas fire in the sitting room, writing with a pencil and a pad of paper. One of my evening-class students went straight to his local library after work every Thursday. Each week, he was scribbling frantically as the librarians went around turning lights off and pushing chairs back under tables. He wrote at other times as well, when he could fit it in, but that two hours of hurried scrawl was his core time, the one time he never sacrificed for anything.

What is your core time? Where is the regular space in your life when nothing short of nuclear disaster on your doorstep stops you from sitting down at your keyboard or with pen and paper? While we are at it, where will your core time take place? Since having children, I have found it increasingly difficult to write novels at home. I can write journalism, do admin or emails. I can rewrite but the really tough, coal-face stuff, the first draft of a work of fiction, has to be written elsewhere; a library, a studio, a rented room, anywhere but home. This causes an obvious problem. I have to factor commuting time into my

time available to write. Wouldn't the time I spend waiting at the bus stop be better spent at my desk?

Over the years, I have found that I can justify giving up writing time to commute to a place where it is easier to write, as long as that process of commuting becomes part of my own personal warm-up routine, i.e. as long as I think about my writing as I sit on the bus, lay out my papers at the library or go for a coffee, it isn't time wasted. By the time I get down to it properly, I may have used up an hour or so of my available time, but I am raring to go.

It may be something else for you – sorting your pencils, making a hot drink, running up and down the stairs four times. In my young, idealistic days, I was scornful of such small tricks, believing that the ability to write was something that hit you like a bolt of lightning rather than a habit that could be developed over time. Five novels, five radio plays and two children later, I've changed my tune. I can't afford to waste time sitting around waiting for lightning to strike. It's my job and I need to get on with it. My own little preparation routine – commute, coffee, write – helps me do that. Over time, you too will learn to recognise what helps you write and then do it each time. Eventually, like Pavlov's dog, you will bark on command.

Look at your diary until your eyes water and work out exactly what (and where, and how) your core time is. Surround it with barbed wire.

WEEK 9

'I thought that she was a stranger asking for directions however it turns out that I was the one seriously off course.' That was the beginning of a response to the 'lost' exercise, posted on the website by 'Merry'. What followed was almost a short story in its own right: a woman driving her car has been stopped by another who approaches and taps on the driver's window. When the first woman winds the window down, the second says, 'It's me', and the first realises — it is her husband's mistress. 'The car window was sent up as quickly as it had come down, my head straightened and I heard my voice

calmly state that I had nothing to say to her. Looking back, I can see that her daring approach and eagerness to tell me where I was on the love map was the moment I stopped being lost.'

A lot of people interpreted 'lost' in this sense. There were moving stories of how lost someone felt when a loved one died, often a parent upon whom they had depended. A writer calling himself 'Blockhead' wrote a seemingly straightforward account of a couple's argument about money during a night out in Dublin. In the taxi home, there was a bleak silence. 'We were both thinking the same thing but the words would not form. After all the drugs, the needles, the breathless measuring out of doses, the echoing hospital foyers, the inevitable signs that heralded the start of her period, what were we left with? A silent taxi. A silent womb.' The word 'lost' was never mentioned, but what the couple were losing was clear.

Not everyone interpreted the word metaphorically and some of the simple descriptions were equally intriguing. 'I got lost in the winter,' wrote Hannah, opening a creepily effective description of snow falling, darkness imminent. 'The only sign of life was a single plume of smoke, snatched and feathered by the wind, out on the far side of the village, and the smell of burnt wood hung heavy in the air . . . and then, on the road out towards the moor, was a figure. A man stood, waiting.' Her short paragraph was laden with Gothic gloom and it was impossible to read it without wanting to know what was going

to happen. Many of those who wrote in captured this so well, the drama of being lost and the feeling that anything might occur next.

This is why lost incidents are such rich material for fiction. A novel that begins with a character astray in a strange or sinister place is going to have an automatic hook for the reader – and if you think this is merely a trick for the thriller/ghost/horror market, read Ian McEwan's *The Child in Time*. His account of a father losing his young daughter in a supermarket is one of the most chilling and compulsive episodes in contemporary fiction, and a great opener for a novel that is a gripping story as well as a meditation on what all of us lose as we become adult.

EXERCISE 5

This exercise is the third and final one of what we might call the autobiographical set. In many ways this is the hardest, because it is the one that could be interpreted most broadly of all. I want you to write an account of a time when you felt trapped.

Sit and think about this for a minute. Most of us have had accidents and most of us have got lost at sometime or another. Fewer of us have been physically trapped, as in locked in a cupboard or stuck in a lift. There might be some of you who have been physically imprisoned in some way, but my guess is that most of you will think of times when you have felt trapped by simple circumstance, in an unhappy relationship or an unpleasant job. Again, feel free to fictionalise it as much or as little as you like. Whichever way you interpret it, what I want you to think about before you start writing is, how did it *actually feel*: that intense sense of claustrophobia or panic, or anger, perhaps? To do this, you may need to spend as much time thinking about it as you will writing it. That's fine. Time to go for that jog or walk around the block? If it's a story from your distant past, then consider get-

ting out a few old photographs and flicking through them, or going to the library and looking up newspapers from that year to remind you what life was like then. When you come to write the incident up, remember the facts of the event but feel free to embroider them as much as you like, maybe using some unrelated material from those photographs or newspapers in whatever way strikes you as interesting. These are the sorts of ways in which fictions are created, not necessarily summoned from thin air, but using remembered incidents as a little kick or starting point for your imagination. In the following chapters, we will move on to the ways in which you can take such material forward.

WEEK 10

Here is a conversation I overheard on a train a few years ago. I am not making this up. Two men in smart suits sat down opposite me. One was in his sixties, the other younger. They had clearly not seen each other for a while and were catching up, chatting about work and mutual acquaintances. After a few minutes, the older one said to the younger, 'And how is your novel going? Are you still working on the same one?'

'Oh yes,' said the younger man. 'I've been working really hard on it recently. It's going really well.'

There was a short pause, then the older man said,

'You've been working on it for some time now, haven't you?'

'Three years.'

'Oh, very good.'

'Yes, it's going really well at the moment, the last few months in particular, I feel I really have made progress.'

Another pause. 'When do you think you might finish it?'

'Well, I don't know really, but it's going really well. I'm really pleased with what I've done.'

After a few more exchanges, during which the younger man kept insisting how brilliantly it was going, the older man became a little impatient. 'Look,' he said, 'you have been working on this for a while, are you sure there isn't a bit of a problem?'

The younger man gave a concessionary nod. 'Well, it *is* going really well, but I suppose I have got just one little difficulty that is holding me up just a tiny bit . . .' I was all ears. '. . . I can't think of a plot.'

Why did I ask you to do those autobiographical exercises? Why didn't I swing straight into telling you how to actually write? That stage will come (believe me, it will), but before you get anywhere near it, there is a very necessary stage that many budding authors forget. I suppose we might call it the 'gathering material' stage.

It is easy to skip this stage without even realising that is what you are doing. Such is the passion to write, that many authors jump in with both feet when they

don't really have anything to write about. I wrote two unpublished novels in my twenties: one total rubbish, the other slightly better. I don't regret them because I learned a huge amount that was necessary to my development as a writer but even if I had been a much better prose stylist at the time, it wouldn't have helped. The subject matter of the books (me, largely) just wasn't interesting. I wrote about myself because I didn't really know what I wanted to write about.

Sometimes, the only way to find out what you want to write about is to write, as widely and as diversely as possible, and for the vast majority of writers, there is a certain amount of writing-about-themselves that needs to be got out of the way before they can start to develop a fully fledged fiction. Even if you have an idea for a novel, that doesn't mean you have a plot. A plot is not an idea, it is a whole mass of ideas, often in conflict with each other, which are expressed by a series of events. To have enough material for a whole novel, you have to be prepared to look way beyond your original idea, beyond yourself, to give it context and development, and above all to introduce the possibility of change. This is the essential difference between a short story and a novel, apart from the obvious one of length. A short story often turns on a moment in time, a visual picture or a point of realisation. For a novel, things have to have movement – a main character has to change or develop in some fundamental way. To put it simply, in a novel, things happen.

This is why I have been getting you to write about accidents, being lost or being trapped, to try to generate ideas in your head for things that might happen to the characters in your novel that might have meaning and consequence for them. In the early stages of writing, it is easy to be afraid of dramatic events because you are worried that you don't have the technical ability to handle them. The result is often writing that is dull and static, whole novels about characters taking tea or going to the shops or realising they are bit unhappy. Don't be afraid of drama. Have an aeroplane crashing on the high street, or an armed siege in an old people's home. It doesn't mean your book has turned into an episode of *Emmerdale*. If you write it well enough, you'll get away with it. Be bold.

Those first three exercises were about generating material but also about trying to demonstrate how material for a novel can, of course, come from your own life but please, *make it the interesting bits*. Most writers spend most of their lives writing, and, by and large, that doesn't make for interesting fiction. The fiction has to come in three ways – either from taking a dramatic previous life and fictionalising it (William Golding made good use of his youthful experience as a merchant seaman); from taking an isolated incident and using it as a kicking-off point to launch into a fully fictionalised work; or from pure imagination. In short, if there is nothing dramatic in your life worth fictionalising, you are going to have to make it up.

In the next few chapters, we will be looking at ways of going about that — ways of departing from your own experience and stretching your imagination as far as it can go.

WEEK 11

When I asked readers of the *Telegraph* to write about being trapped, some of them did it with an efficacy that made my flesh creep. Jill Anabona Smith wrote of being stuck in a Tube carriage, 'Kitten16' was trapped in a lift, while an author called Astra described a potholing experience that confirmed my long-held belief that people who do it are barking.

I liked the telling details many used to create an evocative scenario. Lorraine recalled an incident of forty-five years ago, when a junior school roof collapsed on her and her classmates. As she lay awaiting rescue, she noticed a

crate of empty milk bottles: 'those small one-third-of-a-pint bottles, each of their metal caps pierced by a vertical straw and covered in a thick coat of plaster dust that reminded me of snow'. The author 'expat' wrote of being trapped on a sofa by her cat. 'His lovely, green eyes, the exact colour of pistachio kernels, gaze at me.'

Some went on entertaining flights of fancy. An author called Vivie began her website posting, 'The love of a doll is a dangerous thing.' The ambiguity of that first sentence is deliberate. The narrator's acquisition, a china doll with real hair, is a motionless but increasingly sinister object. Eventually, the narrator shuts her in a chest. 'I made the softest bed. Delicate acid-free tissue, finest linen napkins hand-embroidered with quaint initials, a quilted satin night-case as a pillow. And in she went. I know where hate lies. At the very back of that bottom drawer.'

Fear and hatred cropped up fairly frequently, as well they might in an exercise that involved plumbing some dark depths. 'You'll die before me,' began Iain McGarry's strange and effective rant against a close individual who was trapping him in guilt.

'I am small with childlessness,' said Sarah Be, at the start of a *cri de cœur* from a woman who yearns for 'the entrapments of babyhood'. What was clear was how much the writers were brimming with passions and yearnings. All good writing has passion behind it.

How does a novelist take those passions, and the incidents through which they are manifested, and turn them

into a credible, whole work of fiction? It's a long and complex process. Once you have learned to express yourself and to write about yourself succinctly and evocatively – no mean feat – then the next step is to stretch your imagination, to cherry-pick the interesting incidents and emotions from your real life and put a fictional spin on them or give them to a fictional character with an agenda entirely separate from your own. To this end, the next three exercises involve putting yourself to one side and taking a leap into the unknown.

EXERCISE 6

Do you have a globe or an atlas in the house? If not, buy or borrow one. Sit down somewhere where you will be undisturbed for a while. Spin your globe or leaf through your atlas. Pick a country, but not the country where you live or any other country that you are particularly familiar with. Ideally, I would like you to choose somewhere you have never even visited. Do a bit of basic research on that country: climate, history, names of towns and cities. This will be easier for those of you with Internet access but those without can go to their local library or to a bookshop that sells travel guides. Read as much as you can and try to get as broad as possible picture of your chosen country.

I want you to create an entirely fictional character from that country and write a paragraph in which that person introduces him or herself. Let's say you have chosen Guatemala. The result might be, 'My name is Fernando Gomez. I am forty-five years old and I work as a basket weaver in a suburb of Quetzaltenango. My father was a mestizo but my mother was a Mayan, which is why my skin is so dark. She died when I was two . . .' and so

on. You don't need to know everything about a foreign culture to do this. If you can't find out anything you need to know – a typical name for a Tibetan businessman or the breakfast habits of an Icelandic goatherd – then make it up. You can always correct it later. The point is not to feel restricted in your writing by the limits of your knowledge, and not to be afraid of using a voice that is radically different from your own. It's scary, but once you get going, it is immensely liberating too.

WEEK 12

The previous chapter's exercise – creating a fictional character from a foreign country – was one that involved a fair amount of work. This will happen more and more as this book progresses and the exercises get more complex. By now I hope that you have sorted out a regular time to work on your writing each week and that even if you complete an exercise swiftly, you will be working on separate ideas of your own, sometimes inspired by what I suggest and sometimes nothing to do with it. I like to think that every week you are writing something, even if it's only a paragraph or a few notes

with no form to them. Don't be afraid of experimenting or writing very loose, first-draft material. Every small amount you write is a step forward and even if you end up editing that small amount at a later date, or axing it completely, you will have learned during the process of writing it. You will have moved forward.

The foreign-character exercise was intended to send you off on a journey. For some of you, that journey will end when you have completed the paragraph I asked you to write, but it's equally possible that some of you will engage with that foreign character and enjoy writing in his or her voice enough to want to take it further. There is something wonderfully freeing about writing a short story or even a whole novel from the point of view of someone utterly different from yourself. You will be faced with the exciting challenge of evoking a setting that may also be unfamiliar to many of your readers; the smells and sights and sounds of a foreign environment. Those challenges are productive. They lead to ideas.

Even if you are already working on a novel, it is still important to be open to exploring other ideas, particularly if you are a bit stuck or wondering how to proceed. If your novel is about office intrigue in Milton Keynes, you may not have considered having one of your characters being born and raised in Alaska, but why not? How has that boy who grew up in downtown Anchorage ended up in an office job? Did his English mother walk out on his American father when he was eight and bring him back to this country? Does he spend his time at his

desk dreaming of glaciers and bald eagles? Developing ideas for a novel is often a matter of asking yourself a series of questions. Just how, and why, has so-and-so got from A to B? Arbitrarily changing a character's age, gender or nationality can sometimes free them up, turn them into something much more interesting, and so unlock a whole book.

A small example. Some years ago I had an idea for a radio play called *Nightworkers*. It was about two Tube maintenance workers whose job was to walk up and down the tunnels at night, when the power was turned off, checking them for explosive devices. One night, they encounter the ghost of a worker who died while building the tunnel a hundred years before. At the end of the play, they discover that they are trapped in the Victorian era themselves.

A Radio 4 producer whom I had worked for before liked the idea and commissioned it, but by the time I had produced the first draft of the script, he was too busy to direct it himself and the project was handed over to a nice Australian producer who was on attachment from the Australian Broadcasting Company. There was one catch. At the end of her attachment, she wanted to take the play back and broadcast it on ABC. So, I was asked, could I – maybe – give it some sort of Australian angle?

What? I thought. An Australian angle, in this play? What do they want – a wallaby hopping down the Tube tunnel?

Gently, they insisted. Grumpily, I returned to my

script. The only option open to me was to change one of my two nightworkers into an Aussie. I started thinking about Australia and the images it conjured; sunlight, big skies, wide-open vistas. What would it be like for someone used to so much space to be stuck in the dark in a Victorian Tube tunnel with a ghost? The character concerned had originally been minor, a foil for the interaction between the main nightworker and the phantom, but suddenly my Australian took on a life of his own. The whole play had a new angle and, of course, became a much better play as a result.

Never be afraid of foreignness, of creating characters who are a different nationality, race or religion from yourself. Getting the details right is often simply a matter of research – and at the end of the day, the common humanity that unites us all, our hopes and fears and dreams, can be applied in fiction to any character from any background.

WEEK 13

Itravelled a long way after setting the foreign-character exercise. I journeyed to Nauru, a tiny island in the Pacific Ocean, the smallest independent republic in the world. I went fishing in Panama. I visited the Kronotsky Reserve in Kamchatka in the northeast of Russia, then popped down to Baku in Azerbaijan for a football match where the ref wrongly awarded a penalty against Neftchi. I was given cause to worry about a boy in Uganda who was waiting for an aid helicopter and ended up really hoping that Dana in Macedonia found her missing son before it was too late.

Many of the characters created from the foreign-country exercise felt so real and immediate it was hard to believe the authors hadn't been there. Many of the paragraphs felt like the opening sections of short stories or novels that I really hoped would continue, engaging combinations of fresh first-person voices with the added intrigue of the unknown worlds in which they lived. Many of the characters commanded the reader's attention from the very first sentence. Who would not want to listen to this Italian, created by AJS: 'You bite your thumb at me? I bite my thumb at you! Eh! It's a big joke. You think so? I, Niccoló Andrea Giovane of Firenza, will stick you like a rat.' Or this Vietnamese farmer, by RussW: 'Please sit down and let me introduce myself to you. My name is Nguyen Ho Ky. Of which I am very proud. My family lives here in Cu Chi. It's a small village on the way to Ho Chi Minh City in South Vietnam. I grow rice. We all do. It's harder to work in the rice paddy now than before the war. As you can see, I only have one leg.' An author calling themselves Saifuddin created this character: 'I take bad record from sekolah so I not job in jabatan. My father job for Jabatan Kerja Raya but nothing me. I Malay boy had to job with Chinese boss.'

One of the website contributors raised an interesting point about the use of dialect or patois in fiction: 'It's quite a tricky balance to strike between authenticity and caricature.' That's true and definitely something to be aware of. I found Saifuddin's character's voice easy enough to follow for a short piece but wondered if it

would be a little wearing if a whole book was written that way – although the poetry in a strong patois voice can be lovely too.

There are various ways round this. A character like Saifuddin's could use more simple English in the body of the narration but lapse into more heavy patois during dialogue, for instance, or when his character becomes stressed or emotional in some way. You might decide to use several narrative voices, some of which are in patois and some not – a good way of bringing tone and variety to a book and distinguishing between different narrators.

Whichever option you choose, if you want to continue with whatever foreign character you may have invented, it doesn't mean you have to abandon the autobiographical material from the first three exercises, or any other material you might already have in your notebook. Try combining seemingly disparate ideas – the conflict between them often provides an interesting and productive dynamic.

EXERCISE 7

This exercise also involves travel of sorts. The past is a foreign country, as we all know, so that is where we are going. I want you to write another paragraph but this time from the point of view of a character living in the past. Choosing your time period is easier than you think. Take a wander through the history books at your library. Look up an object in an encyclopaedia: beehives or spinning wheels or spears. If your nearest bookshop has a local history section, that may well be full of all sorts of interesting booklets and pamphlets. If you like the idea of the recent past, then back copies of newspapers are gold mines.

Again, try to make it a past you are unfamiliar with, by which I mean that if you have a PhD in medieval studies or you're an aficionado of Victorian Gothic novels, then try not to write in that area. Feel free to take it on a step from the foreign-country exercise, if you feel like it. I would like it to be a character-based piece, but it doesn't matter if it is first person or third, past or present tense. Be as wide ranging in your style and content as you like.

WEEK 14

We are getting to the crunch now – perhaps I should have warned you it was coming. So far, it's been relatively easy, after all. The exercises have all fallen into the 'idea-generating' category, with clear guidelines about what you need to do. It would be easy to dedicate this whole book to doing such exercises, each one in a different area, throwing up more and more paragraphs of writing until something catches light and you think, yes, that's what I want to write about. There is no reason why you can't, quite arbitrarily, set such exercises for yourself – if you belong to a writing group of any

sort, then why not take it in turns to dream up a differ-
ent one. I've said it before but I'll say it again: a writer
can't have too many ideas. You might write a few lines as
a result of such an exercise and think, well that's going
nowhere, file it away, and then find that years later you
come across it and suddenly it catches fire. Or you may
be in the middle of writing something completely unre-
lated when it comes to you like a thunderbolt, of course,
that section of writing I did about so-an-so isn't really
about them at all, what I need to do is take that section
about . . . Those sorts of thunderbolts come during the
process of writing. Plunge in and start writing *something*,
That is how the ideas come.

There is no one way to write a novel. All I, or any
novelist, can do is tell you how we do it and hope you
find it useful. But having taken an informal poll among
writer friends, it seems there are certain stages of the
process that we tend to have in common. The first is the
ideas stage, when we have vague thoughts about the area
in which we want to write. It might be no firmer than,
say, knowing that the next book will be set on a boat, or
in medieval France. The main characters might also be
vaguely in our head, like ghosts. We might know that by
the end of the book, such-and-such a character will have
drowned or discovered the truth. Often, it is a single
image that sticks in our head, a picture of someone in a
café or on a cliff, and we end up constructing a whole
novel to explain that image to ourselves. In *The Left Hand
of Darkness*, the American fantasy writer Ursula Le Guin

created a planet where there are no different genders and all the inhabitants are hermaphrodite. Every now and then, they go on heat, like dogs, and temporarily acquire the male or female gender. She made the whole thing up, Le Guin has said, so she could use the sentence, 'The king is pregnant.' The first thing that comes into a novelist's head is rarely the first line. Life would be somewhat easier if it was.

Sometimes, the ideas stage can last several years. I wrote the whole of my second and third novels while the idea of the fourth was bubbling away gently in some dim recess of my brain, a kind of ideas cul-de-sac. Every now and then, I would think, ah yes, *that's* what I'm going to write about as soon as I can, while knowing I still had to get the other books out of the way before I could. If you are a sensible writer, you will make notes during this ideas stage – maybe keep a little notebook just for that novel, start doing the odd bit of reading or research that might be related. If, like me, you are painfully disorganised, you will simply carry it around in your head, like a benign growth, in the full knowledge that one day you will have to make the time to do something about it. The idea-generating exercises in this book so far have been intended to replicate that stage, the brewing stage. As we are trying to get through the whole process of writing a book, that stage has been artificially compressed into a few chapters but you will have to give it as long as it takes.

Sooner or later, though, we all have to take the plunge

and start work on a novel proper – and there is absolutely nothing I can do that will help you decide when that time is or which of the many ideas you may have in your head is right for you to settle down to. Often, you will only find out you are working on the wrong idea after you have put a lot of hours into it, but that is a risk you are just going to have to take. There are no short cuts.

The next chapter includes the last of the idea-generating exercises. After that, it is time to move on to the process of turning those ideas into a book.

WEEK 15

'Today the lady who will be the master's new wife came to visit. Agnes and I were up early, before the light broke, sweeping the rushes and baking the bread, although my hand still aches from the burn.' This was a lovely opener, posted on the website by a Tess W. I'm a sucker for this kind of beginning to a story – straight in there, no messing; a situation and a narrative voice, an event anticipated (the new wife coming) and a mystery to be explained (the burn).

Writing set in the past is often enjoyable for the same reason as writing set in a foreign country or unknown

culture. As well as the story and characters, there is a new world waiting to be discovered. Tess W didn't need to name the year in which her story took place. As soon as we read of servants rising at dawn, we have a strong impression of a past era. A universe is conjured. It's an undeniable narrative hook.

Naming a date can be equally effective if it is done unobtrusively. An author called Richard sent me this response, which had a terrific sense of immediacy. 'Welcome, my friends. The now is May 1381 and I am John Ball a poor priest. Others describe me as tall, gaunt, with lined face, piercing eyes and a deep voice. I care not how they see me; it's my teaching that's important. I trained at St Mary's York, many years ago, before the Plague came to England.' In these few lines, Richard created a narrator who tells us a great deal about himself and the world he lives in, although the character himself is insisting that it is only his teachings that matter. One of the many things that makes writing a historical character such fun is that that character within the fiction is unaware that he or she is 'speaking' to a future reader, so the details of their lives can emerge unselfconsciously through the events of the book. You don't have to know everything about an era to write about it because the characters don't either. As usual, detail is key. One small scene of someone cooking or eating a meal in the fourteenth century will conjure up a picture of their whole lives for the reader.

Again, the range of eras in which responders to the column set their stories was impressive: Chile in the

sixteenth century as a human sacrifice was about to take place; the thirteenth-century siege of Minerve by the Catholic crusaders; the French Revolution; the London Blitz. Common themes were war or civil conflict. Whether it was on board HMS *Tiger* in the North Sea in 1916 or a country home housing evacuees, it was obvious that many felt instinctively that an interesting historical character speaks from an interesting time. This is so self-evidently true, I wondered why we don't make the same assumptions when we try to write novels set in contemporary times. Why is it that when so many new authors write contemporarily, they choose mundane characters who don't do much? If they relocated that character to another century, they would understand straightaway that that character's actions should reflect or say something about the wider world in which the character operates. If you locate a character in the sixteenth century then you feel obliged to find out something about that century and reflect it in the writing; the clothing, the politics, the language. That immediately forces you to write about more than just that character, and that in itself leads to interesting writing. Exactly the same *should* be true of contemporary work. A character in a novel who thinks or talks about nothing but themselves is as boring as someone in real life who does the same. A character whose actions impact upon the world around them, and on whom the world impacts, is instantly more consequential and therefore much more interesting.

EXERCISE 8

The final exercise in the ideas-generating phase is a little more tricky. Again, it is aimed at getting you to look at the world from a different perspective and think of the narrative challenges that offers. I want you to write a paragraph from the point of view of an inanimate object. Anything. In case you think it can't be done, remember Bo Fowler once wrote an entire novel, Sceptism Inc., from the point of view of a shopping trolley. It wasn't even about shopping. It was about organised religion. I'm not expecting you to take this exercise quite that far, but have a go at this more challenging thing before we move on to the most challenging of all – building a novel.

WEEK 16

It never gets easier but it does get more rewarding. Each novel may be as difficult to write as the last – sometimes more so – but with experience comes a certain facility and a degree of self-knowledge that compensates for the sheer graft involved. As a writer, you always have something to learn about yourself and the world around you, and you have a professional interest in staying open to the new. It is one of the many things that make it such a fascinating job.

One of the great things about having an interest in teaching creative writing is that you tend to mix with the

nicer class of novelist, the ones who, like you, believe that enthusing new writers about their craft is enjoyable and worthwhile. One such is the writer Jill Dawson, with whom I taught an Arvon Foundation course in 2005. Jill came up with a great exercise that she borrowed shamelessly from her friend, the Australian novelist Kathryn Heyman, who probably borrowed it from someone else. (That's the way it tends to work with creative writing exercises.) Myself and the sixteen students on the course had to write two lists, with the headings 'Allies' and 'Enemies'. Under Allies, we had to note all the things that helped us to write. Absolutely anything. It might be a person, an encouraging friend. It might be a favourite pen or desk – it might be something much more nebulous, such as a desire to entertain other people. The list could be as long as we liked but we were encouraged to concentrate on the concrete and practical.

Under the list entitled Enemies, we were to write down the things that impeded us – and we were to be ruthlessly honest. We are only talking about enemies of our writing, after all, so a truthful Enemies list might begin with *my children* or *my husband*, even if you dearly love spending time with them. *Especially* if you dearly love spending time with them. The list might continue with *my crushing lack of self-confidence* or *I have absolutely nothing to say*. Maybe after you've done this list, you will think it wise to tear it up into very small pieces.

But apart from shredding them, what can you do about your Enemies? You probably don't want to divorce

the husband who always makes snide remarks about your writing – not over this issue at least. But you could choose to stop discussing your ambitions with him. (Why do you need his approval anyway? Er, hold on while I put down this tin opener and this can of worms.) You probably don't want to rid yourself of Writing Enemy No. 1, the kids, but you might start to think about how you can manage to have more time away from them to write, if that is really what is stopping you. The trick with the Enemies is not to get rid of them altogether but to neutralise them or minimise their effect.

It is just as useful to take a close look at your Allies and work out how you can encourage them or maximise *their* effect. In the workshop run by Jill, I wrote under Allies: 'the knowledge I'm not nearly as talented as I wish I was and that I have to work really really hard if I'm going to get anywhere'. When I read that out to the group, Jill took a deep breath and laid the palms of both hands flat on the desk in front of her. 'Let's try and look at that in a more positive light, shall we?' she said, gently. She was absolutely right. It's always harder to praise yourself than criticise, but if you're making a list of your strengths then there's no point in false modesty. *I work really hard*, is a much more useful way of putting it.

Concentrate on the Allies. Pin the list above your desk or write it in the front of your notebook, if it helps. Don't forget the practical things. Want to know another one of mine? Sugar-free mints. One of the things that used to slow me down was my habit of telling myself I

was hungry or thirsty when all I wanted was an excuse to leave my desk. Sucking sugar-free mints or chewing gum distracts me from that excuse. This causes some practical difficulties when I am working in one of the reading rooms of the British Library where foodstuffs of any sort are strictly banned but I have become expert at unwrapping a mint with my hands inside my handbag – under the guise of fiddling for a pencil – then popping it in my mouth while I pretend to cough. (If anyone from the British Library management reads this, I shall prob-ably receive a letter of official warning.)

Other Allies? Well, having writer friends I can moan to comes fairly high up the list. Economic need is a good one too – although if I was to stick to Jill's advice and phrase that more positively, it should be *I can earn money doing this*.

I'm not pretending for a minute that any of this self-analysis is a substitute for actually writing, or that a pack of Polos is going to hoist you on to the Man Booker shortlist, but if you find yourself stuck at your desk with an hour or two to spare and nothing in your head to write about, then give your Allies and Enemies some serious consideration. Be completely honest, and make sure no one sees it but yourself.

WEEK 17

What is your novel about? The best books are about many things, of course, and the very best often turn out to be about something quite different from the ostensible subject matter. This was something that emerged very clearly when I asked readers to write from the point of view of an inanimate object. In a passage entitled 'The Foundation of Civilization', Bert Dowd wrote from the point of view of a rubber washer: 'I'm really important, so important that the whole of western civilization would go down the tubes without me.' There was more than whimsy to this. The washer, tossed out of

a window by a lazy plumbing apprentice, ends up lying in a garden fantasising about being discovered by 'some archaeologist feller' in years to come and being mistaken for a holy relic. It's about disposability, what we value, self-delusion and a great deal more.

Abby Frye wrote from the point of view of a wireless set purchased by the Jones family at the outbreak of the Second World War. Not only does the wireless have animate thoughts and feelings but so do the other objects in the room, who are less than happy at the attention the Jones's are giving their new prized *objet*. 'The fireplace blew smoke in my direction, resenting the fact that everyone was more interested in my lovely illuminated dial than his fitful, sputtering little flames.' But like the rubber washer, the wireless is to end up preserved in aspic, underused.

Many of the inanimate objects worried whether or not they were being put to their proper purpose; cigarettes dying to be smoked, stiletto-heeled shoes affronted at being tossed to the back of the wardrobe – even a garden hose cowering in a shed in fear of a hosepipe ban. Axes, televisions, toilets, mirrors, computers, books and tea leaves all had their own perspectives but were united in a sort of existential anxiety. 'How impertinent! Puff! Puff! Puff! Ooh! I'm growing . . . Around! Around! . . . Soft-landing. Not too dignified, but in one piece.' The author of that passage, Sally Sue, didn't give any clues but my guess is it is narrated by one of those reusable balloons that whizzes round the room making farting noises when you

let it go. Some contributors to the website begged to be put out of their misery about who, or rather what, the narrator of a piece was. 'I watch them drift like flotsam, eyes wide yet exhausted from the journey . . .' began a piece by 'deb', entitled 'The New Beginning'. It turned out the narrator was the Ellis Island Processing Hall.

What was the point of all this? Well it's possible it may have given some of you ideas for longer pieces. I doubt we'll see a whole novel from the point of view of a deflating balloon but Peter Flynn's piece 'Memoirs of a Knife' definitely had potential for development. More importantly, I wanted this exercise to demonstrate that you can write from the point of view of absolutely anyone or anything, should you so desire. In the early days of a writing career, it is easy to feel as if you don't have any real control over what you write about or how you do it – simple insecurity keeps us conservative. But you *do* have choices. Be bold. Be imaginative. If it doesn't work, you throw it in the bin and try something else . . .

EXERCISE 9

. . . Which brings us back to my opening question, what is your novel about? The time has come to ask yourself this. Many new writers resist this question because all ideas sound naff when they are reduced. Hamlet is about a Danish prince who thinks his uncle murdered his father and can't make up his mind whether or not to take revenge. Jane Eyre is about a plain governess who falls in love with her employer only to discover he's got a mad missus hidden in the attic. This chapter's exercise is simply to complete the sentence, 'My novel is about . . .' Use more than one sentence if you like, but don't witter on about the themes of the book. 'My novel is about loneliness, the futility of existence etc., etc.' That isn't saying anything. What is it about in terms of practicality, of plot? If you haven't got an idea for a novel yet, then make one up, right here and now. None of this is set in stone. When you get to the end of the first draft, you may well find your novel has changed immensely or you have realised it is about something completely different. That is fine. But you have to start somewhere, and here is as good a place as any.

WEEK 18

Many of you will have had this experience: the scene is a party or a chance encounter in the street, the protagonists you and someone you haven't seen for a while.

'So what have you been up to lately?' the someone asks.

You hesitate for a second or two, then against your better judgement you admit, 'Well, actually, I've been getting on with my writing. I'm working on a novel.'

'Oh,' says the someone. There is a moment while they register surprise, possibly envy and almost certainly a little scepticism. Then the killer question, often asked sardonically, 'What is it about?'

It may be reassuring to know that even the most experienced of novelists flounder in response to this one. 'Oh, you know, the usual,' they say. 'Not sure, to be perfectly frank,' they sometimes murmur. Or, wearily, 'I wish I knew.' There is something ineffably embarrassing about reducing a novel to what it is 'about' – it's bad enough when it has to be done in a hundred words for a jacket blurb, but a single sentence? My last novel was about two women who hate each other for thirty years but end up buried in the same grave. I have, of course, just told you very little about what it is 'about'.

New writers trying to answer this question often have an additional difficulty: the secret anxiety, what if someone steals my idea? This seems to worry some people so much that we had better knock it on the head right now as a serious concern. There is, of course, no guarantee that someone won't 'steal' – I prefer 'use' – your idea. All writers are magpies and as the Dan Brown alleged plagiarism case amply illustrated, there is no copyright on ideas, even quite detailed ones – but I have to say, I feel no anxiety whatsoever that any of you out there might rush off and write your own novel about two women who hate each other for thirty years and end up buried in the same grave. As I've said before, an idea is not a novel. It isn't even a plot. You can only plagiarise me by copying a certain amount of my deathless prose, word for word or as near as makes no difference. If you were to write a novel based on the same idea as mine, all I would feel would be a professional curiosity in how you

handled it. (If you did it better than me, I might feel a bit peeved, but that's another matter.)

If you have had a crack at describing what your novel is 'about', as suggested in the last chapter, then you may have felt that a sentence or two is ludicrously little to describe what happens in your novel. That's good. In an ideal world, you should be so brimming with ideas that trying to describe your novel feels like describing a huge bouquet of flowers: well, there's some lilies, and some white tulips in between, oh and some stems of eucalyptus and some grasses at the back and some rather unexpected sweet peas tucked at the bottom . . . The difference being that, unlike a bouquet of flowers, a novel is more than a pretty and deceptively artless display of colour. If we want to define what makes a novel as opposed to a short story, for instance, it is that during the course of it, change occurs to the main character or characters. The events of a novel may or may not be arbitrary in their causes but they rarely are in their effects. Characters get older, die sometimes, leave their spouses or emigrate or simply realise their entire life has been a sham. Even if someone does 'steal' your idea, their execution of it, the way in which they portray those changes, will be entirely their own. The idea itself is no more than the seed.

We spent the first third of this book on idea-generating exercises, and now you (hopefully) have the germ of an idea for a novel, we are going to do some work on developing it to find out if there is enough there to make the

plot of a book. If you have already written a sentence or two on what your novel is about, you may want to continue and expand that to include the idea of how your main characters will change and develop during the course of the book. You can do this in continuous prose or in simple note form, whatever feels right. Start to develop your initial idea in a completely haphazard way, if you like, making the odd note here or there, writing down occasional sentences or paragraphs as they occur to you. Don't worry about how you are going to order it all at this stage, just let it brew.

WEEK 19

When I asked column readers to tell me their ideas for a novel, the answers came thick and fast. Lizzie Da Vail was writing a novel about 'Two women [who] meet in a retirement village and soon discover they started life as the same person.' I immediately wanted to know how she was going to handle that. Another one liner with good potential came from a website regular, 'blockhead'. 'My novel is about a man who discovers a young north African sheltering in his London flat two hours after the capital has been hit by suicide bombs. He must decide whether to hand the intruder in or believe

his pleas of innocence and request for help.' I could see that as a two-hander stage play, one of those short, claustrophobic pieces with a rising crescendo of tension and a violent climax. But if 'blockhead' decided he or she was going to continue it as a novel, it's easy to see where the advantage of that form would lie. If it was a novel as opposed to a stage play, the author could take the reader outside the flat and show scenes of chaos, which would contrast nicely with the quiet tension inside, perhaps. Maybe there could be a third character, a relative of one of the men, who is caught up in the actual bombings and narrates from that perspective. There could be flashbacks to the north African's earlier life, which would gradually reveal truths of which the other protagonist remains ignorant. The possibilities for dramatic irony in that situation are endless.

Developing an idea into a plot involves creating a drama – but it doesn't have to be as action-filled as urban terrorism. Mrs Bruni Hastings sent me an idea set in a Home Counties village with lots of potential for the sort of gentle comedy at which many English writers excel: A local woman has a telephone slot on an American chat show where she tells little vignettes of eccentric English village life. Her husband and the other locals are proud of her, until the American TV show's ratings shoot up and a Hollywood film crew descends upon the village.

So, where now? You have an idea for a novel, or a collection of ideas, but how do you begin to shape them into, say, 80,000 words of flowing prose? Those of you who have

a fairly well-developed plot might like to expand that, per-haps even decide roughly how many chapters you are going to have and start making notes on what should happen in each chapter. But for many of you, your ideas will be at a much earlier stage and you still need to generate more material before you can start shaping it.

The easiest way to do this is through character devel-opment. Once you start asking yourself a series of questions about your characters – their origins, their motivations – then plot developments will follow. You won't be able to use everything you come up with because not all of it will fit into the overall arc of the story, but whichever writing method you use, you are going to have to come to terms with generating material that has to be jettisoned later. There is no way around that one.

EXERCISE 10

Take your main character, or one of them if there are several. Sit down and write a CV for that character; the usual stuff, date of birth, place of birth, education, parents' origins and so on. Do it in either continuous prose or note form, if you like, but don't pay any attention to how much of it might be included in your finished novel. Just get down as many basic details as you can.

WEEK 20

We are now entering Phase 2. For the last nineteen chapters, you have been doing writing exercises designed to get you going, to give you ideas if you had none, or to expand and add diversity to the ideas you might already have. But I've been warning you for some time that there comes a point when you have to just buckle down to it – and now that time has come.

Phase 2 is a tricky time but also an exciting one. At this stage, there is everything to play for. Even if you have a fairly detailed idea about the way you think your novel might go, you know in your heart of hearts – and you do

know, don't you? – that once you get writing, anything can happen. This is what authors mean when they talk about a character taking over a book or having ideas of their own. We're not talking about demonic possession. We are talking about the wonderful alchemy that sometimes occurs when you are in the midst of the writing process. You are writing a scene – say – about two main characters arguing over whose turn it is to take the rubbish out, when it suddenly occurs to you that the reason X doesn't want to do it is not because it is raining outside but because she is scared of bumping into neighbour Y but she can't tell Z that because . . . and so on. It hasn't even occurred to you before that Y might feature heavily in your story – and it wouldn't have occurred to you if you hadn't been writing that argument between X and Z about the rubbish. Ideas about what to write, and the realisation of what you are really writing about, come when you are actually writing. (I know, I've said it before and I'm sure I'll be saying it again. Maybe I should get it tattooed on my forehead.)

So now we begin Phase 2. Get your diary out and take a critical look. Find everything that is cancellable for the next ten weeks, and cancel it. Be ruthless. That weekend trip you didn't really want to go on in the first place? 'I'm sorry, but I'm just entering Phase 2, can we do it in August?' Your Tuesday badminton game? 'I've pulled a hamstring and my doctor says I can't play for, ooh, about ten weeks.' The school run? Time to call in some favours.

When you have made your excuses to all and sundry, I want you to take a clear-eyed look at what time you have available and set yourself a weekly target. How much is entirely up to you. I like to set myself high targets in the full knowledge that I won't make them. They spur me on to write more than if I had set a lower target — a rather ridiculous form of bargaining with myself. Some of you would be disheartened by that and might prefer to set yourselves a low target, in order to be all the more delighted when you achieve better. How high you set the bar depends on your personality type. Be ambitious, though. It's only for ten weeks. For ten weeks, you're going to give it everything you've got.

During this period, continue doing the exercises set in this book but regard them as no more than kick-starters, mini-trampolines to send you bouncing off into the thick of your book. Write a bit of your novel every week, but do it haphazardly. If, for instance, you have in your mind a dramatic plot development that occurs towards the end — the bus crash that is going to happen in the penultimate chapter, say — then write that, if you feel like it, even if you don't know what leads up to it. If you have in your head a flashback scene but you have no idea where in the novel the flashback will occur, then just go ahead and write it anyway. Don't worry about doing anything chronologically. You might have a picture of something that you want to describe, a housing estate, or a discarded hat, or the view of whitewashed houses from an Athenian tower. You don't have a clue about how it

fits in your book, just a general feeling that, yes, that is part of it and will probably go in somewhere. Go ahead and write it.

Take a scattergun approach. The point of this ten-week stretch is for you to get as many words down on the page as you can, to build up the material for your book, without censoring yourself and without any anxiety about how, or even if, those words will fit into the finished article. Write whatever you feel like writing, as long as you have in your head some vague idea that it might be part of the book eventually. After the next ten chapters, we will take a breather and look at what you've got, but between now and then, go for it in a wild, enthusiastic and entirely unplanned manner. The chapters that come between now and then are designed to provoke the sort of disorganised development that I am talking about, starting with the basic one: character.

WEEK 21

The CV exercise produced diverse results. Many people wrote lists or streams of consciousness, giving just the bare facts of their characters' lives. Others wrote potted biographies or introductory paragraphs. A Kristin posted a message on the website that was a fiction within a fiction: 'Please find enclosed my CV and application form for the part-time vacancy in the One-Stop Convenience Store, Cliftonville Branch. I can only work for 15 hours a week. If I do more my income support will be stopped. CV: Sadie Joan Olds. DOB: 19.8.79. Place of birth: Margate, Kent. Mother: Dead – heroin overdose . . .' and

so on. This may not have been exactly what I asked for but it was a nice trope that gave some narrative flavour as well as that sort of information. Many included background flavour almost inadvertently. Jeffgwatts (sic) wrote a CV for a character he called Marathur: '53 years old. Older brother of Phillipus. Although Marathur had the brains, Phillipus had the charisma and it was inevitable who would become chairman of the senate on their father's death.' It may be in note form, but the reader could guess at the crisp, urgent writing style that this author was likely to use.

There was some debate on the message board about who had done the exercise correctly, which forced me to point out that as far as my exercises were concerned, there was only one way to get things right or wrong. Writing was right. Not writing was wrong. I set the exercises with a certain methodology in mind that I believed in because it worked for me. I was pleased if people followed it, but flying off on a tangent was and is absolutely fine, as long as you are actually writing something.

Many wrote passages where the character described was clearly being set up for some sort of dramatic event. JMJ wrote, 'My main male character is a popular, likeable chap . . . above average intelligence. Did okay at school and university – could have done better with more work and less sport and drinking . . . cannot cope with displays of emotion.' With a character like this, it is obvious that something calamitous has to happen to him early in the novel, an event that will turn his life

upside-down in the most unexpected way, for both him and the reader.

You might find it useful to extend your character CVs or potted histories. Ask yourself a series of questions. What is your character's favourite food? Colour? Television programme? Often, nothing will come from these lists other than a vague feeling that you are getting to know your character better, but sometimes you will come up with something that will prove crucial for the development of the book. The Russian novelist Turgenev reputedly spent weeks writing enormous biographies for even minor characters, then going through them with a blue pen and highlighting what he was going to include in the finished work. Many novelists don't feel the need to go that far, but it is certainly useful for getting ideas about how a character might respond to events within your book.

Much of this basic groundwork is something you can do on your own — along with writing your weekly allowance of continuous fictional prose — but I am going to set a couple of exercises that will make you think about your character in a slightly more lateral way.

EXERCISE 11

Write a paragraph or two of fiction from the point of view of your main character, which includes an incident during which they break their thumb. No, you won't necessarily have to include it in your finished novel – although I am rather tickled by the possibility of a future PhD thesis in which some twenty-first century academic earnestly discusses the importance of thumb-breaking in the literature of the early part of the new millennium. If you don't want your main character to break their thumb in the novel itself, then this exercise can simply become part of the background material that you will later discard. But do it anyway. You will discover things about your character you didn't know; how accident-prone they are, how vulnerable, their response to pain or misfortune, and that is material that you may be able to use in some other way.

WEEK 22

How are you getting on with the ten-week plan? Hard, isn't it? Hard to find the time, hard not to listen to those negative little voices in your head: *Who'd be interested in reading this? This is so dull. It's never going to be published anyway, so what's the point?* If it's any consolation, there isn't a writer alive, published or unpublished, who doesn't hear those voices. We all have our own self-destructive little habits. My favourite is the phrases in my head from the bad reviews of the previous novel, phrases that replay endlessly, like a tape on a loop, while I'm trying to write the current one. It doesn't matter how

many good reviews the same book received, it's the phrases from the bad ones that stick. You think rejection slips are bad. You wait until your rejections are expanded to several hundred words and printed for all to read in the pages of a national newspaper.

This is why many of us feel an understandable desire for approval at a very early stage of our writing – a stage when the writing itself doesn't really bear external examination. In choosing examples from the results of the exercises to quote in the newspaper column, I always felt acutely aware that there were hundreds of other equally interesting examples I could have chosen and worried that the contributors who were not mentioned by name felt slighted or discouraged. Every week, there were dozens of additional examples of good or interesting writing that I didn't have room for. Reading this in book form, you may occasionally feel that you missed the boat in some way and would have liked to have been quoted in a newspaper too, but pleasing as it may have been to those I picked, the important thing was and is to do the actual writing. It is very, very hard, but in the early stages you have to soldier on without a pat on the back from me or anyone else.

When I did the creative writing course at the University of East Anglia, I attended a seminar where we were discussing the work of one of our number, the Irish writer Anne Enright. We were all a little in awe of Anne. At the time, she was an unpublished student like the rest of us, in her early twenties and endearingly all

over the place, but her talents were so manifest that it surprised no one when she became an acclaimed novelist within what felt like about two hours of us all leaving the course.

In this particular seminar, we had all read a section of her novel-in-progress and had been discussing the minutiae of it for a couple of hours, which in Anne's case consisted of us taking it in turns to pick out which sentences we thought particularly brilliant. Towards the end of the seminar, Anne tossed her manuscript pages on the floor and turned to our tutor, Malcolm Bradbury. 'Look,' she said, 'there's only one thing I want to know about my novel.' We all stared at her. 'Does it stink?'

However confident you are about your desire to write or your prose style, you will find yourself asking that of each individual book. Does it stink? You will ask yourself it continually, even though you know the only way to find out is to spend a year or more writing the darn thing.

There are lots of writers around who have a more psychologically intuitive approach than mine. Those writers might tell you there are various strategies for avoiding that question and other similarly negative ones – visualisations, hypnotherapy – but being a blunt rationalist I am going to insist there is no substitute for putting the words on the page. I've used this analogy before but I really do think it is a bit like dieting. A novel is written in increments, just as a weight-loss plan happens pound by pound. Every paragraph you write is a

paragraph nearer to the end of your first draft. And, just like dieting, it is important to realise that there will always be times when it's one step forward, two steps back. There will be days or weeks where you don't make your word count, just as there are days when dieters tuck into fish and chips. The main thing is not to get disheartened by those days and end up using them as an excuse to give up altogether. Start each writing session with a clean slate in your head – it doesn't matter if what you wrote yesterday was rubbish or if you wrote nothing at all.

It is also important not to worry *too* much about quality control during this stage. If your novel does stink, there will come a time when some of it – perhaps a lot – will have to moulded, trimmed or ditched altogether, but there is no point in worrying about that now. Your sole concern should be getting words on the page, regardless of how well you wrote yesterday or how much you will have to rewrite it tomorrow. A Scarlett O'Hara-like optimism and determination is the only way to get through it as you sit down at your desk each day. *Today is the first day of the rest of my novel.*

WEEK 23

Just how many ways are there for somebody to break their thumb? Well, several hundred as it turned out; falling off a bike or down a railway siding, sticking it up a bath tap, trapping it in a filing cabinet . . . And that's not counting the ways in which fictional characters had their thumbs broken by somebody else. Heavy objects were wielded, murder victims fought back, sadists snapped them for no reason at all. The comic episodes I was sent were painful and the painful ones comic. That's thumbs for you, I suppose.

What was interesting about the results of this exercise was how many of the respondents did much more than write a piece about a character breaking his or her thumb. Knowing that there are a million ways in which it might happen, they chose ways that illustrated how that particular character might behave or react. 'Sometimes I felt that my dad wished I had been a boy . . .' began JMJ, as he related a go-karting incident that wasn't really about thumbs at all but about how much children want to protect their parents. 'I knew my dad would need looking after when he got back from the hospital but I was only seven and didn't know how to help him.'

A writer called Rosie sent me a short paragraph in which the painful throbbing of her character's thumb – broken when her mother threw a saucepan at her – comes as a relief. 'Now she has something to show others – and which she can acknowledge herself.' The physical injury was emblematic of the deeper, more nebulous emotional suffering that lay beneath.

Here was what I hoped became obvious to anyone who attempted the thumb exercise – that if you have a character in mind for your novel, and that character is growing into someone convincing and real, then it is impossible to write a physical event like breaking a thumb without revealing something about them. You don't have to be heavy-handed about it. You don't have to say, 'So-and-so had always hated anyone making a fuss of her and was very proud.' Instead, you write a

scene in which so-and-so breaks their thumb and bad-
temperedly refuses help, and your reader gets the
message. It is one of the cardinal rules of fiction-writ-
ing, which the more experienced among you will have
heard many times: don't tell, show. This is something
we will be returning to again and again, and is why,
during this character-building phase, I want you to
write episodes of concrete, physical action, rather than
asking you to tell me what you think your character is
like.

One of the most entertaining thumb episodes posted
on the website came from the author Priscus. 'The
Captain's Thumb' described an incident where a woman
breaks her thumb as she descends the steps of a ship. 'It
had to be PO Drysdale waiting at the bottom, didn't it?
When I was still three steps up, he threw up a smart one
and snapped, "Guard of honour ready for your inspec-
tion, Ma'am" . . .' After the accident, the narrator tells
us, 'The FSL was quite sympathetic; he said, we let you
go through the Glass Ceiling, and you promptly hit the
Steel Floor.' I had no idea what a PO or FSL was – still
don't – but I didn't need to know. In that small incident,
I got an evocative snapshot picture of a smart, funny
woman and her unusual life, and I wanted to know
more.

'Today I am fifteen years old . . .' began a story by
the author Ruth. It was pure incident. A young girl
pushes a lecherous old man away from her in a cherry
orchard. He falls against a tree and calls out that he

has broken his thumb. She stops, about to return to him, and already we are shouting, 'No, don't go back!' Incidents have consequences. A story is underway.

EXERCISE 12

Write another incident. In this one, I want your main character to wake up in the middle of the night. Just that. They might wake from a nightmare, perhaps, or because they hear a noise – or they might not know what has awoken them. What do they do? Stagger to the bathroom, check the time, or go straight back to sleep? Do they drift to the window and stare out at the grey light outside? Are they fearful, irritated, excited? What I am thinking about is a sense of the 'otherness' of night-time, the way in which thoughts or truths that we don't normally have during daylight hours can sometimes surface. It might be a point of realisation for your character or it might be nothing at all – seemingly nothing, for in a novel, every incident counts, even if you're not sure how at the time.

WEEK 24

I bet when you first thought about writing a novel, a year seemed like quite a reasonable amount of time to do it, didn't it? Time enough to write and time enough to investigate all of the basic aspects of novel-writing, character development, description, plot . . . but if you've been reading this book week by week, you are now nearly halfway through your year and maybe – just maybe – starting to panic a wee bit. At the very least, you almost certainly haven't written as much as you would have liked to. I am not being patronising here – if

I were trying to get through the first draft of a book in a year, I would be feeling exactly the same.

All novelists write slowly in the early stages of a new book, when they are still feeling their way around, trying to work out what the hell is going on. The first quarter of a book can take ten times as long to write as the last quarter. Towards the end, everything starts to pull together. You see the thing as a whole. The strands knit, and you can write very fast. In the early stages, the opposite is true — all those strands are still to be invented. There are often innumerable false starts. You may be working very hard and feeling that you're not seeing a great deal for it: odd scenes here and there, perhaps, some character development and the occasional plot idea, but still no coherent shape as a novel. This is normal. There isn't a novelist on the planet who sits down with the book fully formed in his or her head. Just like you or me, they all have to start somewhere, and false starts are part of the process.

Half the battle is having something to write about, which is why the first half of this book has been dedicated to idea-generating exercises that you may or may not use in your book. Nothing is wasted. Everything is part of the learning process and sometimes it is possible to reuse something you have discarded from a novel in a different format. The last short story I had broadcast on BBC Radio 4 was an offcut from my fourth novel. This particular section was a self-contained flashback revealing a secret belonging to one of my characters, Josef — that his

family were once slaves. I was convinced the reader needed to know this about Josef, now a respected community leader and a proud man – but when it came to my final draft I realised that, although I was pleased with the episode as a piece of writing, the reader didn't actually *need* to know about Josef's background for my plot to progress – it had no relevance in that respect – and there simply wasn't a place in the book where the flashback fitted in that didn't impede the forward motion of the novel. Believe me, I tried hard to find one. Nothing is harder than axing a scene you know to be well written, but sometimes you have to steel yourself to do it for the good of the novel as a whole. There will be compensations. Apart from the possibility of recycling it, writing that scene teaches you something about those characters and feeds into the way they behave in other scenes. My readers never knew that Josef came from slave stock, but I knew, and it informed his behaviour in all sorts of other, more subtle ways.

You, too, will find this happening once you have written enough episodes and spread them out before you. Many of your scenes may be sketchily written, but you will begin to see how it all slots into place, and which are the things that absolutely must happen for your novel to be the novel you intend. You will see the episodes that hold it together, and then you can start to fill in the gaps. Don't be disheartened by a lack of coherence at this stage. You have to write a certain amount before you can step back and see the whole picture of the

jigsaw. The main point at this stage is to build up a body of material to give shape to later on.

If you haven't taken to the character-building exercises I have set so far – the broken thumb and the waking at night – then invent your own. They might be things that will be included in your finished novel, or they might not. Remember that intensely curious phase when you first meet a lover and want to know all about them? Discover that curiosity about the main character, or characters, of your novel – if you aren't at least a little bit in love with them, you can't expect your readers to be either. Your characters don't have to be likeable, but they do have to be engaging.

The next exercise is the final one before we start assembling the jigsaw.

WEEK 25

'Alan Jones, whose real name was Joe Gouder, was having nightmares again, and this time Mr and Mrs Jackman decided they had had enough of being woken by his muffled sounds of panic. It was only six weeks since this strange secretive man had shown up at the Jackmans' appropriately named Prince of Paupers public house, hidden away in the dingy back-streets behind Great Yarmouth's plastic and neon Golden Mile, and offered to work behind the bar in return for a bed and board and a few pounds spend-ing money.'

The writer who sent in this response to the waking-at-night exercise called him or herself David Cook, but I was a little suspicious – the name sounded too simple and the writing had a finished quality. There's a lot of information packed into those first two sentences, a technique I sometimes find off-putting, but 'David Cook' gets away with it because he or she keeps their language simple and there's a strong narrative hook. James Joyce used the same technique in his short stories. It comes down to a confidence of tone, a prose style that jumps straight into the story. It is always all right – better than all right – to use one of my exercises as a trampoline.

Many stuck to the brief more closely and those results were also pleasing – the quality of writing in this batch of responses was high. Many captured the fearfulness of being awake at night but also the beauty and excitement of it. 'Early in my childhood I fell madly in love with the strange otherness of night. I loved words like twilight, dusk, midnight, starlight, moonlight. The word glimmer I especially loved because that's what the stars did . . .' wrote Drumboorian. Several wrote of that odd experience of dreaming of being awake. AJS captured the panic of it: 'The dark would not release him. Then, suddenly, he was awake. A howlish moan was in his ears. It was coming from his own throat. He gulped air . . . He was unable to move.' Dreams often took characters back to an unexplained past. Vivie wrote: 'He dreamed again of his gestation. He had heard the tales, over and over. His mother had sheltered in the *sottosuolo*,

the silent subterranean city, during pregnancy. When the bombing raids had become too dangerous, whole families had survived underground.' The advantage of beginning a story with a dream is that you are often straight into a dramatic event, a crisis or catharsis in a character's life.

Quite apart from the psychological uses of dreams, the very act of waking at night, when the world can often seem like a much more complex or threatening place, is a good way to open up narrative possibilities. Allyson Dowling had a character awoken by the sound of a toilet flushing. Leaving her partner asleep, the character stumbles blearily downstairs to put the kettle on. It is only as she is listening to the kettle boiling that she thinks to ask herself, but if my partner is still in bed, then who was flushing the toilet? The author Merri had another woman awakening to find her bed empty. The man she had picked up the night before is no longer lying beside her. She rises and goes to find him. 'As she reached the bedroom door, she had a clear view into her kitchen where he sat in his tatty boxer shorts, tapping ash from a lit cigarette into one of her coffee cups . . . shuffling through her pile of bills and paperwork she had messily thrown on the kitchen table.' The possible explanations for this scenario are endless, and endlessly sinister.

EXERCISE 13

The last of our three character-development exercises is a little more complex than the previous two. I want you to pause for a moment, and think about what the main character in your novel wants – wants in the grand sense of the word – out of life. We have already discussed the importance of drama and conflict in a book – even if it is of the subtle or comic kind. If your book is going to have some sort of conflict then something, or someone, is stopping your character from achieving their goal. I want you to write a passage in which your character confronts what is impeding them. Your character could have a row, or write a letter, or merely fantasise about what he or she would say to their obstacle – or, you could write a piece from the point of view of the obstacle, telling us what he or she thinks of your main character. Either is fine – just give us some idea of the challenges your character is going to face as they struggle through the maze of your book.

WEEK 26

We are now six weeks into the ten-week plan, the phase where you have corralled as much time as you can and are writing as hard as possible. As well as the exercises in this book, I hope you are also writing all sorts of other scenes, notes or fragments, odd little things that occur to you, snippets of dialogue, bits of description and so on. These don't have to be coherent or organised, just whatever comes into your head. Ideally, the exercises are no more than the tip of the iceberg – never stop just because you feel an exercise is concluded. Go off on as many tangents as you like.

I always know that a novel has begun to come alive in my head when I start viewing everyday life through its prism. Sitting on a bus, seeing an elderly man bent double in the street outside, I might think, 'Ah, the way he is walking, with that stick held out in front of him, that's interesting. That's exactly how so and so would walk as she goes to see her daughter about . . .' This is one of the ways in which the material for a whole novel is built up, by the book living in your head so much that almost everything that happens to you as you go about your daily business feels like raw material. It's a useful process for one's art – although I'm not sure I can claim it's a particularly healthy way to live one's life.

To give you an example of how extreme this kind of experience-filtering can become: when I was working on *Fires in the Dark*, I had an accident. Rushing to cross a busy street, I got my legs tangled up with someone trying to do the same and flew face first on to the road with such force that I broke my nose, lost two teeth and was lucky not to fracture my jaw. I can still remember the clear sensation of flight as my feet left the ground, the split second of knowledge before all thought was knocked out of me by the impact. And I can remember the howl I gave as I lay in the road, a desperate, animal noise that stopped passing pedestrians in their tracks.

Want to know what I thought as I sat in the ambulance on the way to hospital, covered in blood? 'Hmmm . . .' I thought, as the little spots began to dance before my eyes and the paramedic slapped an oxygen mask over my

mouth and nose, '. . . this is real pain. I must remember what this feels like. *I can use this in my novel*.' (I did, in case you're interested, it's there in Chapter 14.)

Start noticing the things in your life that might be useful. When you feel cold rage because that woman pushed ahead of you in the queue at the post office, make an internal note about what that sort of anger feels like, the thoughts that go through your head. Be observant all the time, both about the world around you and your reactions to it. It doesn't have to be anything dramatic. It might just be the colour of the sky, that strange grey-yellow glow it can have at the end of a sunny afternoon when it's going to rain that evening. It might be the way a casual acquaintance scratches their ear. Many, many years ago, I met a woman who breathed with her mouth open all the time and made a constant clicking sound with the phlegm at the back of her throat. That strange, unpleasant noise stayed in my head for over a decade, until I needed to describe a minor character succinctly and evocatively, and suddenly there it was, popping up unbidden from the weird subconscious filing system at the back of my brain. (Sensible novelists keep a notebook but I've never quite got around to it. Don't follow me on this one, though. Think of all the useful observations and ideas I must have forgotten, over the years.)

Don't wait for the exercises in the alternate chapters here to give you a kick-start. Start using the world around you. Even things that don't seem immediately relevant to the novel you are working on at the moment

are worth noting. You have four more weeks to write willy-nilly, recklessly, before we sit down and start to pull it all together.

Enjoy this bit. Don't censor yourself. Don't worry about the overall shape of the book. There'll be plenty of time for that in the weeks to come.

WEEK 27

Families. Where would novelists be without them? Well, we'd have a lot more time on our hands, but just think of all that raw material we would lose. It was interesting to read how many of the 'obstacle' scenes involved mothers and daughters or fathers and sons. Some of these confrontations were violent, such as this, from Steve1: 'Richard opened the door and stepped straight into the path of his father. "Where have you been?" the man asked immediately. "It was a long walk home," Richard replied. "That is not what I asked you," said Arthur. "I asked you where you had been." "I have

been walking home, father," said Richard, and felt the sharp sting of an open hand slapped across the mouth.'

There was an added twist to this story. The father says that he has been up to the school and 'Father Peder assures me that he has not seen you all day, nor the day before.' It seems as though this is a tale of simple truancy, until we are told, 'Richard's mouth dropped open in shock. He had been at school the whole time – what reason would the monk have to lie?'

Not all of the parent–child confrontations were violent. Some were touchingly gentle. Marina wrote of a young woman plucking up the courage to tell her mother she is leaving home: 'Signora Conti has asked me to go with her as her maid. She says she will pay me twice as much as the theatre management and I will live with her wherever she goes. It would mean going to Rome with her on the coach at the end of the month.' This simple scene was an eloquent example of how the obstacles in life can come from those who care for us as well as from those who don't.

The variety of obstacles the characters faced was impressive. Tarric had to sew a body into a sack. Serafin was looking for a boy called Feliciano but three violent youths stood in his way. Susanne was on a doorstep pleading with an unpleasant individual called Carl: 'Please tell her, I'm so sorry.' And how was John, a Quaker, going to persuade the tribunal chairman that he is refusing to fight the Germans out of moral conviction?

'Mankind doesn't need Art,' said G. K. Chesterton,

'what he needs is stories.' I wouldn't say the two are mutually exclusive myself, but as a nascent novelist you can't go wrong by concentrating on story for now. If, in this material-gathering stage, you are ever stuck for a plot development or a way forward, then think about where the conflict in your story lies. What obstacles are in the path of your main character – and your minor characters too – and how will she, he or they overcome them?

To this end, the next exercise is a partial return to the autobiographical ones from the early part of this book. I say partial, because by now I am hoping that you are experienced enough to know how to take an incident or emotion from your own life and apply it to a fictional character.

What makes you angry? I mean truly angry, angry enough to do something you might later regret. I nearly punched another mother in a play centre once – I won't go into the details except to say that so obnoxious was her behaviour that I would have had a pretty good case in court. I'm glad I didn't for many reasons, not least of which is that punching people is wrong, but I still fantasise about it occasionally when I am wound up about other entirely unconnected issues. The great thing about writing fiction is that your character *can* punch other people – although, as in real life, they have to take the consequences.

EXERCISE 14

Use the obstacle incident, if you like, and take it one step further – how does your main character overcome that obstacle? – or, create a completely different scenario that arouses real anger in a character in your book. What action does she take? Does he capitulate and find a way round it? Does she run in the opposite direction? If there isn't an obvious place in your novel for a character to become angry, then take some of your own anger (about anything) and give it to a character quite arbitrarily, even a minor one. It might not be something personal that makes your character angry – it might be the big, important stuff, a miscarriage of justice, global poverty, or the maltreatment of one individual child. Try giving one of your characters your own deeply held moral convictions. If it is emotionally true for you, there is a much better chance it will be convincing to a reader too.

WEEK 28

How is your stamina holding up? I only ask because the stage you are at now is one I always find challenging. Ideally, you have a growing body of material to work with – scenes, fragments, ideas in note form – but there is a strong possibility it still doesn't have any shape. Or maybe you are finding it *really* tough. You've done some of the exercises. You still think your idea is worth pursuing but haven't written nearly as much as you would have liked and it's all proving much, much harder than you thought. Every writer has those days when it just won't come, when language itself seems as slippery

and unmanageable as an octopus. On those days, it is easy to despair, particularly if you have made sacrifices to buy time to write and you feel as though that precious time is dribbling through your hands like so much water.

If you only have a couple of hours, then you are probably best off sticking with it and writing *something*, even if it's only a paragraph. If you are completely stuck, pick up whichever book you are reading at the moment, preferably one that is related in some way or another to the novel you are working on yourself. Read, but read critically, with half your thoughts on how what you are reading might be relevant to your own work.

If you have set aside a longer period to write, a day or more, and still feel intently that it just won't come, there is something else you can try. It involves getting away from your screen or desk, which may be exactly what you need. Find your notebook and preferably a camera as well. Put on your shoes. You are going to visit your novel.

Whenever I am stuck on plot or character development, or just feeling ragged and unsure where it's all going, I go off and research setting. There is something wonderful about gazing upon the physical landscape of your book. It isn't just a matter of being able to add a sentence or two of authentic description, it is a question of steeping yourself in the atmosphere of your book, inhabiting the world of your characters. The final section of *Fires in the Dark* took place during the Prague Uprising of May 1945. I had already sold the book by the time I

came to write that section, so I was lucky enough to have the resources to visit Prague. I had been before as a tourist, with my family in tow, but at that stage I didn't have a clear idea of what was going to happen at the end of my novel – on this second trip I knew what, but I wasn't sure how. Before I went, I found an historian who was an expert on that period and took him my Prague street map. I got him to mark on it the streets where the main events of the Uprising had taken place and any-where else he thought might be of interest to me. Then, I spent four days roaming those streets, slowly, as I was heavily pregnant at the time, working out how long it took to get from location to location, noting the narrow-ness of buildings or the shapes of windows. I went to a deserted military museum and looked at uniforms, street signs and motorbikes from the period of the Nazi occu-pation. I wandered across Charles Bridge and around the Little Quarter. I saw the tiny barred window of a cellar room, which I decided was the room that one character and her family would use to hide in during the worst of the fighting. I used a fraction of the detail I gathered in the book itself, but I got numerous ideas for how my main character was going to survive the Uprising. Each evening, alone in my hotel room, I wrote like crazy.

You don't have to be writing historical fiction for that kind of research to be relevant. On a somewhat more mundane level, my second novel necessitated a day when I jumped on the Northern Line and got the Tube to Edgware. *Dance with Me* had a shifty villain called Peter,

the helicopter pilot I mentioned in Chapter 5 of this book. Having been up in the chopper, I now wanted to know where Peter lived. To this day, I have no idea why I chose Edgware, except that I wanted him to live in one of those strange hinterlands on the outer reaches of London, an area with a combination of cheap and expensive housing, anonymous, commuter-belt land with no discernible character of its own. When I got off the Tube, I went to a local estate agent's office and gazed in their window until I found a house that looked like the one that Peter might own. I had only the vaguest of ideas about what I was looking for, something large and fairly expensive, a house with tall privet hedges – the sort of place where the neighbours wouldn't pry. When I found a house that looked a likely candidate, I went for a walk down the road where it was situated and as I walked around the empty, midweek streets, I started to think about Peter. He was single, so why did he need a large home? Why did he want something that was smart but unflashy, the kind of place that wouldn't stand out? By the time I got to the end of that road, I knew what the secret in Peter's past was, why he owned an expensive house and why he would decide to alter his will a week before he died.

Cameras are useful on a trip like this because, if you look at a photo after the event, while still thinking about your character, it is sometimes possible to spot things you didn't notice when you were taking the snap – like seeing a ghost that wasn't there at the time. Even the way

the light falls can suddenly seem like an answer to why a character behaves in a certain way. Not all of these details are useful, but the ones that are are gold dust.

If your novel is set abroad or in the past, then going on location may not seem like an option but think inventively. If you are writing about a sixteenth-century courtesan then go to your local haberdasher's or department store and finger their most expensive reams of satin or lace. How does it feel? How would you fasten it, or get the mud-stains out of the hem? If your book is set in Portugal but you can't afford to get on a plane, then find a Portuguese restaurant and order a dish you've never heard of. Ask if you can stand in the kitchen and watch them cook it. Most people are very helpful if you tell them you are a novelist, but if you think they might not be, then fib. I didn't need to see inside that house in Edgware but if I had, I would have simply gone into the estate agent posing as a buyer.

There are few novels that would not benefit from this sort of lateral research in the early stages. One writer who followed the newspaper column and contributed regularly to the website used the moniker Potternut and was writing a novel about dragons. I don't know whether Potternut ever followed my advice but I suggested to him (I'm afraid I did assume it was a him) that he should go to the local woods and find the sort of tree his dragon liked to sit on, or rock, or whatever. Even if you're writing fantasy, it still has to be real. Real lives are not just about the things we say to each other or the thoughts we

have. They are full of textures; of sights, sounds and sensations, so start thinking laterally about the texture of your characters' lives. Find their natural habitat. Note it, draw it, photograph it. You may not use that photograph or that piece of lace immediately, but it can go in the pile of material that informs your book, a scrapbook of your novel, if you like.

Box files are useful for this. In the early stages of a new novel I will throw in anything I think might be part of my new work, even if I'm not sure where or even whether it will be used. By the time I am ready to write, that ordinary grey thing with its lever arch has become a Pandora's Box.

WEEK 29

Two chapters ago I proposed a vote of thanks, on behalf of all writers, to our families – the arguments, betrayals and general all-round resentment. What rich material. There's gold in them thar hills.

But as the results of the 'anger' exercise reminded me, we shouldn't forget romantic attachments. I got an entire novel out of a bad relationship, back in the early days. From the work they sent in, the writers who followed the column clearly agreed: when it comes to unleashing a few choice sentences of vindictive prose, there's nothing quite like being humiliated in love. Lorraine wrote a piece called

'The Wimpy Bar', in which a teenage girl takes impetuous and bloody revenge on her boyfriend across a Formica tabletop: 'He'd broken her heart; she'd broken his nose.' An author called Strang sent in a bizarre but hilarious story entitled 'Royal Rage', in which a future queen of an independent Scotland was being blackmailed by an ex-lover who wanted her to pass an enabling bill for an industrial complex in the Western Highlands: 'What he expected, I don't know. I pushed the red button under the table twice, summoning six men. I waited, sitting quite still and glowering balefully at him (I hope). The door crashed open, and the Guard poured in. "Arrest that man," I yelled, springing from my chair, "manacle him hand and foot to his seat. If he resists, hit him as hard as you must."' There are times when every girl needs an armed guard, clearly.

More chilling were the stories where anger had gone cold and set as hard as concrete. In a piece by Les Chattell, a character called Roger listened to an audio tape that he had hidden in his girlfriend's pocket when she went to a dance with his friend. Roger didn't like what he heard. 'The smooching periods were far too quiet to be anything but smooching . . .' A nicely ambiguous sentence that implied Roger may have been imagining the whole thing. Meanwhile, his mother was trying to get him out of bed. 'WORK, Rog.' He clearly had a fairly mundane sort of life, but as he cycled off that morning, 'his belted knife rubbed his hip sore'.

Many touched upon the interesting grey area where moral anger leads to the desire for potentially dispro-

portionate revenge. AJS wrote about a Jewish-American soldier in the Second World War, beating up a German Waffen SS officer. Ruth described the discovery of a child abuser who had been tortured to death: '"His punishment is but a shadow of his crimes," read the note left by the man's mutilated body.' This piece, by the way, opened with a classic example of suspense writing: 'The people in the village heard his dog whining. They waited another day to investigate, so when they found the old man he had been dead for at least two days and the dog, tied up outside, was frantic and starving.'

I hope that by now you are starting to feel that you know your main character or characters fairly well. You have written their CVs. You have broken their thumbs and given them insomnia. You have set obstacles in their paths and described how they might overcome them – and what makes them angry. Will you use any of these episodes in your novel? It doesn't matter if you don't. What you know of your characters will inform your writing even if you choose not to share it with the reader. Thinking laterally about the individuals who people your book can give you all sorts of ideas for how the plot of the book might develop, ideas you may not have had if you hadn't written scenes that might end up discarded.

This chapter brings us to the final week of the ten-week phase and so a vital stage. We will be moving on to plotting and narrative construction, the mechanics of how we take all your hard work over the previous weeks and begin to put it together into something resembling a book.

EXERCISE 15

Now for the last of the 'character-development' exercises. For this final one, I thought I would chose something simple. Write a section in which you describe what your character looks like. They might gaze into a mirror. They might look at a photo of themselves. Or the piece might be written from the point of view of someone else entirely, another character in the novel giving us his or her perspective. Aim for two things: economy and detail. Don't do a police photofit description, blond hair, brown eyes etc., concentrate on the small, telling pieces of information that make a character live for the reader.

WEEK 30

Congratulations, the ten weeks are up. You have made it to the end of Phase 2, the early, material-gathering stage, where you have been writing all over the place.

You probably haven't written as much as you would have liked to. Does that matter? No. Word counts are there to aspire to, like New Year resolutions. The point of them is to write something that you wouldn't have written if you hadn't set yourself that target, not to obsess over whether you made the target itself.

Hopefully, you now have what might be referred to

as a body of material. With me, that might consist of, say, a couple of complete chapters, not necessarily from the beginning of the book, half a dozen scenes that are written in very loose, first-draft prose – probably including one or two segments of varying length that I'm pleased with and know will appear in the finished novel more or less as they are. There will also be odd paragraphs or even single sentences on bits of paper – perhaps a page torn from my diary where I have had a thought on the bus and scribbled it down. There could be some research notes or photographs, or even leaflets on various topics.

Now comes the really exciting part – it's almost my favourite bit of the whole process. Find a large flat surface. A desk or table might do but if you've got a lot of stuff you might need the floor. Spread it all out, sit back, and gaze at it.

Bit of a mess, eh? Well, let's tidy up. Let's say, you have one scene that you are really pleased with – the moment when x confronts y about z. Read it through and have a think about it. Is it a climactic scene, something that will occur, say, three-quarters of the way through? Or is it an opener, the catalyst that sets the whole novel in motion? You are going to put your stuff in a rough line that represents the chronological progression of your book, so if it is an opening scene, then put that at or near the beginning of the line. Pick up another piece of paper. Let's say, when you were in the travel agent four months ago, you picked up a leaflet about Croatia, because you had an idea that maybe x goes

on a business trip to Croatia and it is at that point that she realises she must tell z the truth. Does that trip to Croatia come after the confrontation with y or before? Go through all the loose bits of paper or other material that you have and put things very roughly in order.

Don't rush this. Once you have a very rough chronology, if you sit and stare at it, maybe with a nice cup of tea or stiff gin in hand, it might come to you that, actually, things could work another way around. Try swapping your material around a bit and stare at it a bit more. Sometimes, a moment of realisation comes – oh, hang on, that bit where Cortez's mistress falls in love with the Portuguese translator, that's got to happen earlier because . . . or maybe you'll think, no no no, if Brigitta discovers her uncle's body *then*, that will mean that there is no time to . . . Those sorts of thoughts are much easier to have when it's all spread out before you. All you have done is enabled yourself to step back and look at your book as a whole, to see the wood for the trees.

Crucially, you will begin to see where there are gaps. Make notes on sheets of paper and put them in the gaps. You might write a note saying something as general as 'ship sinks' or 'Tom leaves home' – doesn't matter how vague. Put it in the place where you think that event might occur.

What do you do with this line of stuff once you have put it roughly in order? If you can leave it spread out without other family members trampling all over it or the dog running off with a vital piece of paper, you might

like to do that, so you can return to it and mull it over. If there isn't too much material there, you might like to stick it on the wall. I often divide it up into three or four piles: *these* things happen in roughly the first third or quarter of the book, *these* in the middle section(s), and *these* in the last. When the piles are collated, I push them to the back of my desk and as new scenes are written or new ideas occur to me, they are slipped into the relevant pile. Remember that none of this is set in stone.

But before you pile your material up or put it in envelopes or stick it on the wall, allow yourself a moment of pleasure. Here, before you, is your novel. Yes, it's a mess. Yes, it's got more holes than an abandoned cobweb. And, yes, you are going to have to work harder than you have ever worked in your life to fill in the gaps and re-order it if necessary – and, crikey, we haven't even got started on the quality of your prose yet. But you have an idea for a book and it has shape and form, and now the real work can begin.

WEEK 31

Y ou have taken the material you have gathered over the previous seven months, spread it out and put it into chronological order as it occurs in your book. You have also filled in a few of the gaps in note form, if possible. You were creating a plot.

It really is as simple as that. When you are working on your first book, it is easy to believe that there is some holy mystery to plotting or structuring a novel but, at its most basic level, it is no more than a matter of you the novelist deciding that this will happen, then this, then that . . . and if it doesn't work that way then you will

change it. It took so much of this book to get to that point because, as you may have discovered, it is very hard to think up a plot in isolation when you don't really know what you want you to write about. It is much easier if you have a body of material to work with. Writers are often asked, do you plan your novels before you start writing them? I have never met an author who sat down and drew up a detailed plot before they wrote a word, although it's possible such writers exist. Now you are well into your novel proper, you will have to stop and do some planning ahead (or behind) occasionally, but that should never stop you actually writing. Often, the only way to discover what happens next is to start writing and see what comes.

From here on in, we are going to concentrate on different aspects of technique. Some of the exercises that follow may prompt you to write episodes of your novel but it is important that you are also working on your book independently of the exercises, filling in those gaps when you can, making the odd note here and there.

Getting you to write a physical description of a character in your novel was part of this new phase, because it is often in physical description that the flaws in a writer's technique are most obvious. Put another way, there is something about describing the way a person looks that seems to bring out the clichés like flying ants on a hot summer's day. Blondes are always busty, old people rheumy-eyed and wrinkled and babies chubby of cheek. We are told that a character is short or tall, stout

or slim, and it feels like meaningless information that is only there to provide pointless padding for a story lacking in focus. The best and most evocative descriptive passages are always blended seamlessly with an advancing story. BigT wrote about a character staying late at work when she hears a strange noise coming from her boss's office. She discovers him lying on the floor. 'Gucci clad, sockless feet . . . He was conscious, but obviously could not move . . . his blonde ponytail lay across his neck and spittle was running across his cheek leaving a glossy trail.' The description appears to be incidental to the action but his designer-style arrogance will clearly be relevant to what happens next. Good description always has a dual purpose: to advance the plot or tell us something important as well as to create a visual picture. 'The summer before he started secondary school Lupe learned that he was black.' That was a classic descriptive opener, from Angelica. Immediately, we learned a great deal more than the simple information that Lupe is black and probably around eleven years old. We learned that his age-appropriate naivety was about to be shattered by external forces – we were propelled forward into a story.

For the next exercise, we are going to continue with the idea that everything you write has a dual purpose.

EXERCISE 16

Go back to the material you spread across the floor last week and pick a gap. Any gap. I could tell you just to decide what is going to happen – but as you've probably realised by now, I like to come at things from an oblique angle. You don't have to make a narrative decision at this stage, but try thinking about this: what is the weather doing at the time? Write a description of weather – cloudbursts and thunderstorms, shimmering heat or just plain grey – but as you do it, try to think of the way in which this weather description might be relevant to what is actually happening in this scene. Does it prompt the characters involved to a course of action? Does it simply create a sense of mood? Think of it as more than just weather, but the setting in which something will actually happen.

WEEK 32

I suppose I should be honest and say that, in a sense, we are getting ahead of ourselves. We have moved on to discussing different aspects of technique but if you really have been writing for only thirty-two weeks, then it's too early. In an ideal world, I would encourage you to continue writing loosely and chaotically for the rest of this year, take a six-month break, and only then go back to your messy first draft, start to order it more carefully and hone your prose. Compressing the process of writing a novel into a single year has its obvious drawbacks — not least of which is that there will come a point, if there

hasn't already, when you just want to put the whole thing aside for a bit.

If I were trying to write a novel by following the chapters in this book, I would definitely feel like taking a break around now. Writing hard is often something that seems to come in waves. I set aside a block of time – between six and ten weeks is common – where I write as much as possible, and at the end of it I feel worn out, fed up with it. Like all working parents, I moan about the school holidays and how impossible it is to get any work done, when in fact there's nothing better than stopping for a bit to take the kids to the zoo and eat too much ice cream. Even those of you who aren't rearing school-aged children are likely to need a break from your writing at some point, when you go off for a bit and do something completely unconnected with your work.

I suppose I should be cracking the whip over your head relentlessly for the whole of this book, demanding that you stick to your weekly quota at all costs and telling you it's absolutely essential you write something every day. All I can say is it would be dreadfully hypocritical of me to do that as I certainly don't do it myself. Even with a publisher's deadline looming, I can go weeks without writing anything, sometimes for childcare reasons or because I have other work commitments, sometimes because I can't seem to get a handle on what I am supposed to be writing about and even thinking about it feels like wading through mud. I wouldn't dignify it with the phrase writer's block. Writer's sludge is more like it.

During these periods, I get progressively more glum and convinced I will never write again – then, out of nowhere, comes a surge of energy. For no apparent reason, things click into place and I throw myself into another stretch where I write like a lunatic, sometimes thousands of words a day. It's a bit bipolar, I suppose, and not to be recommended if you can avoid it. If there are any of you out there who do it more methodically, then hats off to you.

If you are fairly new at this game, then the problem you may have is judging when you are not writing because you are taking a psychologically necessary break and when you are not writing simply because it's too much like hard work and you just can't make yourself do it. In making that judgement, I'm afraid you are on your own – only you can be honest with yourself. All I will say is, if you give yourself permission to take a break, set a firm date for when that break will end and then take time off with a clear conscience. Put this book and the material for your novel to one side and agree with yourself that you will do nothing for three weeks, say, or whatever you feel you need. Enjoy the break and do something that has nothing to do with words. Go to art galleries or for long walks, if you are able to do so. Paint the bathroom or build sandcastles with the children. Start a course in the cha-cha-cha. If you let your life suffer too much because of your art then eventually your art will suffer too. If you stay absorbed in a book day in day out for a very long period, it is possible to go a bit mad.

If you are not comfortable with putting your brain on ice for this 'off' period, then read. You might read books that are tangentially related to your own work, or something completely unrelated. At the beginning of the year I talked about how important it is to read voraciously – not just research for your novel but other novels that will inspire or teach you something. I have often kick-started myself out of a 'writer's sludge' period by reading an interesting, flawed book that has made me think, ah yes, that is the way to do it/not do it. Often, answers are hidden in the most unexpected places.

Having just told you it's okay to take a break if you really need to, I am now going to carry on regardless. The next chapter is all about those weather descriptions. As I write, on a laptop in a café, an irritating French chanteur is moaning through the speakers and rain is dripping thickly off the red awning outside the window . . .

WEEK 33

There was something quite exhausting about reading the weather descriptions I was sent. Blizzards, sandstorms, swirling mists, oppressive heat – not to mention the rain: there was lots, and lots, of rain. Sometimes the weather was the point, as well as a backdrop. Gayle wrote a piece entitled 'My Rectangle': 'Lying here with the plastic hospital mattress beneath my incapacitated body, my view of the outside world is made up almost entirely of weather. My very own rectangle of changeable sky is interrupted by a single steel chimney. Belonging to the kitchen or hospital laundry

perhaps? I have plenty of time to consider such minor details . . . I still hope I'll see my last proper storm.' Weather as an irritant was a common theme. Paul wrote, 'I sit cross-legged, like the Buddha, trying to meditate. The monk in front of me seems to be in a trance. Perhaps he is used to this stifling midday heat. I feel a bead of sweat drop from my forehead on to the saffron robe I am wearing . . . A fly lands on my shaved head and starts to walk across my scalp. I suppress an urge to kill it. It is one of Buddha's little creatures after all, possibly an ancestor, but obviously a very annoying one.' That description was ostensibly about the heat of the day but what drew me in was the gently comic portrayal of a young man – I had an image of someone white and inexperienced – trying to meditate in a foreign climate with distinctly uncalming results. What the hell was he doing there? He seemed to be wondering that too. Writing is always engaging when it purports to be about one thing but is clearly about something else. In the middle of that 'stifling midday heat' there was a story going on.

Some of the purely descriptive passages were also very evocative. 'All the greys are out today . . .' wrote Kate. 'Last night the mist rolled in, slowly creeping from the stream, whispery tendrils stretching out, expanding a vague domain.' An equally evocative atmosphere of another sort was achieved in 'Gone Fishing' by Lorraine: 'A sultry August afternoon on the bank beside the sluggish river, the stillness of the thick summer air weighing

heavily on her supine body, Fran mustered just enough stamina to turn her head towards her Grandfather as he bent to adjust his rod . . .' A child's response to the weather often seems more natural and engaging, some-how, perhaps because a child narrator doesn't freight their description with significance in the way that adult narrators often do.

One thing that struck me from the submissions was that even the really interesting passages could have ben-efited from a little pruning. Take this sentence, from Vaughan: 'The sun blazed onto the arid Spanish plain, desiccating the dried out soil into dust, or, where there had been moisture, into dun coloured blocks of earth as hard as concrete.' 'Arid', 'desiccating' and 'dried' all say the same thing. And I couldn't help wondering if we *really* needed to know the plain was Spanish this early. 'The sun blazed onto the plain, desiccating the soil into dust or into dun coloured blocks of earth as hard as con-crete.' It's tighter and it says almost everything that the first version did. Good as Kate's description of the grey mist was, did we need the words 'slowly', 'whispery' or even 'out'? Try removing them and see how it reads then. Is anything really lost?

We'll be discussing how to rewrite your work in more detail in subsequent chapters but it is worth learning the trick of 'trimming as you go' as soon as possible: it makes life so much easier later on. In his book *On Writing*, Stephen King offers the simple formula: second draft = first draft −10 per cent. That may sound

reductive, in more ways than one, but I doubt if you will harm your work if you follow it and you may improve it enormously. For the next exercise, I am going to push you even further . . .

EXERCISE 17

Pick a section of your writing – either one of the descriptive passages you have done recently or something completely different. Do a word count, then cut your words by at least a quarter. Start by cutting all the adverbs, then the adjectives. Don't just cut out whole paragraphs; that's cheating. I want you to trim sentence by sentence, so that everything that happens in the first version is still there, but pared down to the bone. When you have done this, put the two versions aside for a few days before going back to them. Read the short version first. You may decide to put back in the odd word here or there, but I'll be surprised if after honest analysis you think the longer version is better.

WEEK 34

One of the questions often raised by new authors is how they will know when to cut their work. As a general rule, large-scale edits, cutting whole chunks or moving them around, often has to wait until you have completed your first draft. Only then can you step back from it and see what needs to be axed. But the sort of trimming I was talking about in the last chapter – the nip 'n' tuck here and there, the tightening up of your prose – should become a daily instinct. If you can get in the habit of 'editing as you go', it will save you an awful lot of time later and, more importantly, will help you make the

more difficult decisions about whether or not to cut whole sections. The big rewrites, the structural decisions, are much easier if your manuscript isn't clouded with bad, over-written prose that fogs your view of the wider picture.

I hesitate to insist that you get into good edit-as-you-go habits this early in the game. If this is your first year of writing, then the most important thing is that you are encouraged and egged on towards that vital first draft. I wrote reams of rubbish before I managed anything publishable and if I had taken a serious look at my work at that stage it might have stopped me in my tracks. But I'm betting on you being more mature and honest than I was at that stage (you almost certainly are). You will save yourself acres of time if you start to develop self-critical habits now. In case there is any risk that this could slow you down, let me say again: *I'm not talking about restructuring.* I'm talking about the minutiae – realising that too many adverbs make for melodrama, not emphasis, and that contrary to popular mythology, novelists do not get paid by the metaphor.

I appreciate it is hard, though, particularly if you are doing a word count every day and willing yourself to reach a certain target. There's nothing worse than triumphantly dashing off 2000 words only to realise the next day that half of them have to go. Two steps forward, one step back, is the way that many novelists progress – and we all have to come to terms with the fact that some days the equation works the other way around. I wouldn't

advise heavy rewriting every day but I would advise this. Each time you sit down to write, read through what you wrote last time and trim the odd word here or there. You should never feel comfortable reading your own work unless you have a pen in your hand or a finger close to the delete key.

This is an appropriate place to talk about cliché. I've already mentioned how often clichés can appear in descriptive passages but, let's be honest, first-draft writing of any sort is often dripping with them. There is a good reason for this. By way of demonstration, try this little test. Pick up a biro or pencil. Yes, right now. Ready? Right. You have five seconds. In the margin of this book or on a piece of scrap paper if you prefer, draw a cat.

One, two, three, four, five. Stop.

What have you drawn? Well, let me guess. Two circles, one on top of the other, with two triangles on top, and maybe three lines in two fan shapes either side of the top circle. Ever seen a cat that really looks like that? Nope, me neither. But I only gave you five seconds. There wasn't time to draw a real cat. Instead, you drew the sign for a cat. Signs are something we use all the time. When you are driving along the motorway, you know that a picture of a knife and fork by the roadside means a service station with food, not a pile of knives and forks. When you are writing fiction, particularly first-draft fiction written at speed, it is very easy to use the verbal equivalent of those signs – clichés – because

you are concentrating on getting the words on the page. It doesn't mean you have to throw your work in the bin the next day, but it does mean you have to be ruthless with yourself later on. The first thing any art teacher tells a child is to draw what they really see, rather than what they think something ought to look like. The same is true of writing. *The sky was blue*. How often is the sky really blue? And even when it is, how many different types of blue are there? How uniform are they? *She was an attractive young woman*. Was she, really? Why? Just because she was working behind a bar or hotel reception desk? If you want to describe a real bar worker or receptionist, then go and take a look at some. Some are attractive, some not. Some are male. Some are old. Some have gold fillings or never look you in the eye. Write what you really see, rather than what you think you ought to see. There is a much better chance it will then feel real to your readers as well.

WEEK 35

When this book was a newspaper column, I some-
times got myself in a bit of a pickle. The
'trimming' exercise was a classic example. What I hadn't
clearly thought through was that for the exercise to work
properly I, and any of those responding to work posted
on the website, really needed to see both versions. Some
contributors got round this by posting the longer ver-
sions of their work, then the shorter ones as a response
to their own posting. (Clever types, these writers.)
Others posted the two versions separately but the eccen-
tricities of cyberspace meant that sometimes one or

other of them was sent adrift. Some postings migrated back in time to a previous week's message board, others were destined to wander around the ether for ever, searching for their twin.

Where the two versions of contributors' writing were available, there were some interesting comparisons. Ruth's story, 'Rain', was a good example of how a tighter version of the same incident has more pace. Here is the beginning of the longer version: 'Before dawn Matilde shook me awake and we stood up in our cloaks and gathered our possessions. Her sister kindly gave us each some warm milk and a package of food with bread and cheese and sausage, and we set off to walk the long distance back to the piazza. The cool dawn sky was all thin cloud brightening grey to white and as we walked along a light rain started to fall.'

Compare it with the shorter version: 'Before dawn Matilde shook me awake and we gathered together our possessions ready for the journey back to the piazza. As we walked along in the cool dawn a light rain started to fall.'

The shorter version has more immediacy but, without knowing where it appears within the context of the novel Ruth is writing, it is hard to know whether all her cuts are necessary. As far as I can tell, I think we can do without the cloaks and gathering of possessions. I quite liked the sister giving the package of food, although the warm milk made me wonder if they drank it immediately or carried it, as this piece is clearly set in the days

before thermos flasks. Both pieces are engaging but the shorter undoubtedly has more punch. How ruthless Ruth should be with this section depends on where it occurs within the book. Once your reader is deep into your novel and fully engaged with your story and characters, you can afford more detail than at the very beginning when – at the risk of sounding mercenary – your sole concern should be to pull them in.

It was clear that Ruth's prose style was pretty tight already; what became apparent with great rapidity was that the writers who were most ready to cut their own work were the ones who needed to least – they had already learned to become their own toughest editor. If you were resistant to this exercise, maybe you should ask yourself why. If it was simply that the timing wasn't right and you needed to get more words under your belt before you felt ready for it, then that's fine. If it was because you regard your words as sacrosanct, it isn't. There isn't a good writer on earth who isn't also a good rewriter.

When you look back at your early work, in years to come, what will make you cringe is bad prose. Unconvincing plot developments or poor characterisation will make you wince a bit, but only sloppy, over-written prose will make you want to chew the carpet in embarrassment. In the coming chapters,we will move on to narrative viewpoint and structure but good prose style is so essential I want to stick with it for a bit.

EXERCISE 18

This exercise involves the use of metaphor and metaphorical language. It's very simple. I want you to use one.

As with all the exercises I am setting from now on, what would be most productive is for you to go back to the pile of material you have for your novel and pick another of those gaps. That way, each exercise serves the dual purpose of getting you to think about an aspect of technique while (hopefully) kick-starting you into adding a little bit more to the body of material you have for your book. But if you are still floundering with the concept of your novel, then just think on the hoof.

Write three sentences – no more than three – and include a metaphor. We will then take a look at why they are such dodgy little blighters.

WEEK 36

Back in the days before I published my first book, I remember a conversation with my mother when I asked her if she would be offended if I wrote something sexually explicit. No, she said, it was absolutely up to me what I wrote about. What about violence? No. Political satire? No. Something that poked fun at all the values she held dear? Of course not, she said adamantly. I was a grown woman and as a writer no subject matter should be out of bounds. Then, after a short pause, she added softly, 'But I do hope you won't use bad language.'

Needless to say, I went on to do just that (sorry,

Mum) and my first book had sex, violence, political satire and a couple of 'f' and 'c' words to boot. Oddly, though, I haven't felt the need to swear in my fiction since then. Know what? I think I grew out of it.

I am not trying to proscribe swearing – or sex, or violence – if, as a writer, you feel it's both necessary and true. It is simply that often, when I come across them in a first novel, it is hard not to give a patronising smile and think, gosh, how adolescent. The sex in my first novel was sparse and brief, as befitted the situations of the characters involved, and, at the time, I believed that, because it was appropriate for *them*, that also meant it was necessary to include it in my book. There is no logic to this. We don't feel a portrait of a fictional character is incomplete because we don't know how well they swim or if they like tomatoes, and equally there is no reason why we have to know about their sex lives unless it is integral to the plot. As a character in David Lodge's *The British Museum is Falling Down* observed, 'Literature is mostly about having sex and not much about having children. Life is the other way around.'

The other problem with writing about sex is the danger that your reader will stop reading your novel and start reading the sex. Your writing then gets judged on how well you have handled that one aspect. My first book provoked a furious opinion piece in a tabloid newspaper entitled 'Why Are Our Young Women Novelists So Filthy and Disgusting?'. Yes, that really was the headline and yours truly was singled out as a particularly filthy

and disgusting example. All I can say is readers who rushed out to buy *Crazy Paving* on the strength of that headline would have been seriously disappointed. Most of the violence took place off-stage and the sex scenes were a tiny percentage of what I thought was a very serious novel about chaos theory and urban terrorism – but all that tabloid opinion writer noticed was the dirty bits.

There is also no denying the fact that it is extremely difficult to write about sex well – the same is true of violence, although I dislike the automatic coupling of the two as if they were both inherently and equally dreadful. They aren't – but they are both physical acts and the physical manoeuvring of a character often causes writers difficulties. A character goes out to buy a newspaper. Why does it feel hard to write, 'He went down the street' or, 'He walked down the street'? *Because you don't need it.* Instead, try beginning the next paragraph with, 'In the newsagent's . . .' Equally, if two fictional characters meet and fall in love, then you don't *necessarily* have to describe the first time they have sex. Try 'Afterwards', and then describe the conversation they had, or the meal, or how they went their separate ways. Any of those options can be just as revealing of the characters involved – and possibly more erotic.

In the same way that an explicit description of the sexual act often stops your reader's absorption in your book and makes them take one step back to observe how well or how badly you have pulled off that particular

trick, swearing in fiction can have the effect of distorting the rest of the language you use. Here we come back to our current subject matter, literary style. As a general rule, one swear-word in print does the job of many dozens in real life. You only need to use a handful of 'f' words in a book for the reader to gain the impression that it is full of 'em. I don't know why this should be, unless it is simply indicative of the emotive power that certain words still have in literature, despite their common currency in daily use. By all means use them if you need to, but simply be aware of the effect they are likely to have – is that the one you want to achieve? It is the same with dialect or phonetically rendered speech – a little of it on the page does the job of a great deal of it in real life. Your reader has certain expectations of the language that a novelist uses and confounding those expectations is fine if you have good reason to and you are prepared to handle the consequences. John Fowles, a workaholic obsessive if ever there was one, apparently researched the nuances of Victorian speech very carefully for his novel *The French Lieutenant's Woman*. When he submitted the manuscript to his agent or editor, he was told that the speech sounded too modern. To make it convincing, he had to go back and add a bit of cod Victorian language to fulfil his readers' expectations of how people spoke in the nineteenth century. Any novelist is entitled to stick to what she or he believes in and if this anecdote is true then I'm surprised Fowles didn't. He was not a man afraid of being thought curmudgeonly. But if you *do* stick to your

guns on an issue such as this, you have to be prepared to be misunderstood. Which is more important to you as a writer, purity or clarity? Most of the time you won't have to choose – sometimes, you will.

WEEK 37

What is wrong with the following sentence? 'Rabbit Angstrom trotted down the alleyway holding his jacket like an envelope.' Well, where shall we start? When I first read it, I was genuinely baffled. But envelopes don't wear jackets, I thought. Oh, no, hang on a minute, what the author means is, Rabbit is carrying his jacket in the same way as he would carry an envelope. But jackets are bulky and made of cloth, and envelopes are slim and made of paper. And anyway, are there 'ways' of carrying either of those items? Surely it depends on how big or awkward they are, how heavy, whether it's

raining or not . . . John Updike (for it was he) clearly has a scattergun approach to simile: fire off a load of them and hope that one will hit the mark. When he's good, he's very good, but you have to wade through an awful load of self-regarding tripe to find the bits that work.

Take this, though, another Updike phrase, from the point of view of a young bridegroom glancing sideways at his bride as they stand before the registrar, noting 'the dark star of her lashes'. It's rather nice, I think, a metaphor that feels fitting for the ambiguity of the bridegroom's feelings. The jacket/envelope thing, by contrast, has no relevance to Rabbit's feelings or actions. It is just a pointless bit of business. Look at me, I'm writing!

Many of the metaphors I was sent felt as if the writer was trying too hard. Extended metaphors are particularly tricky, although Bob Egg made this one work: 'Billy's bedroom was that in name only: a room with a bed. In reality, it bore a closer resemblance to a farm.' He then went on to explain the many ways in which it did, and got away with it – just. That aside, most of the best metaphors I was sent were brief and to the point, like this from AJS: 'Niccolò was quicksilver. He had the speed and the temperament. He was a dangerous friend.' Metaphors can also be verbs, as a writer called DtheR pointed out on the message board. I rather liked this from an author called 'mud': 'Mosquitos fizzed about his head.' An appropriate metaphorical verb in an otherwise simple sentence can be very effective. A simile used as a throwaway line often works well too, such as this from

Claudia: '"You seen the girl your brother's dating – she's beautiful." My mother wrestles with an anaemic lump of pasta dough . . . the table shudders and a fine dust ball of flour rises up like sea spray from a plummeting stone.' The simile here is a by-the-by illustration. It works because it isn't showing off.

The difference between a simile and metaphor is very simple: a simile uses 'like' or 'as' before it – it is a simple comparison. A metaphor, according to the *OED*, is an 'application of a name or descriptive term to an object to which it is not literally applicable'. In other words, no 'like' or 'as' required. Both might fall broadly into the term 'metaphorical language', which new novelists are often inordinately fond of because it makes them feel more like writers to use it. It is dangerous stuff, though. Used properly, it produces fireworks. Done badly, it can blow up in your face. Now there's a metaphor that doesn't work.

Pick up the body of material you have for your novel, or, failing that, anything you have been working on recently. Read some of it or flick through it, and ask yourself this: When you look at the nuts and bolts of it, what is it about the writing process that you find most difficult? Of the many technical aspects of using language, which bit most baffles or confounds you? This might be a minor aspect of grammar, or even a word that you know you often misspell. I avoided colons for years because I didn't know how to use them. Eventually, I went away and looked them up. I probably still get it wrong sometimes but I'm not afraid of them any more. It might be a broader subject than that; description, say, or writing about how a character feels.

If there is an aspect of grammar that you have been avoiding out of habit, then go and look it up in a guidance to style – preferably more than one as sometimes they disagree. Teach yourself how to use it. If it is a wider issue – the use of the present tense, say – then experiment. Write a passage in the present tense to see what it feels like. If you find it hard to write about a character

having interior thought, then pick three different characters from your book and write a paragraph of interior thought for each.

Write a list of all the technical aspects of writing that you find most challenging, then work your way through them, one by one, having a go at each. Do what you are most afraid of.

WEEK 38

Before we move on from the subject of prose style, there is one more thing that must be said about the use of metaphorical language. If in doubt, don't. A plain sentence can be a thing of beauty. A metaphor that works is also beautiful but a failed metaphor will stop your reader in their tracks. 'His eyes rolled around the room.' No, they didn't. 'She felt her heart leap into her mouth.' *Eurgh!*

In an early short story, I described a man walking home on a summer's evening. 'Primroses peeped from the hedgerow.' Yes, I really did write that sentence. Those

cheeky little primroses – what *were* they up to? If the literal interpretation of your metaphor is in any way comic or bathetic, then forget it.

Hopefully you are now giving due consideration to the technical aspects of writing that you find trickiest but, as your tutor and friend, it behoves me to throw a few into the pot that you may not have yet considered. When I asked around my novelist friends, curious to see what they could come up with, a useful subject was raised by the author Douglas Kennedy: exposition. If you're new to writing you may not have heard of exposition but if you read novels you will have come across it all the time. Ever wonder why so many novels – even really good novels – can seem slow in the early stages? Ever found yourself reading something that you're sort-of enjoying but with the sense that you are fifty pages in and still waiting for the story to start? Clumsy exposition.

Exposition is, literally, explanation or background-filling. In novel-writing terms, it is the feeling that you really must explain *this* about a character or how will your reader understand why they do *that*. In memoir or autobiography, it is often very obvious: a politician or a celebrity takes us through the minutiae of their childhood before they get anywhere near the bit we are all interested in. Novelists often get tripped up the same way, thinking that unless they introduce us to how the character got to where their story begins, we won't understand the story itself. Kennedy has a good way of

putting it: 'All novels start at a given moment in time which is usually well after the birth of the main character or narrator, which means there is always a story before the story you are reading, a back-story . . . but if you throw too much detail at the reader you can bore them at the moment when you're attempting to hook them, too little and you don't have emotionally complex characters.' Kennedy cheerfully admits that in his first drafts he writes far too much exposition: 'I'm writing my way into the book.' He then has to pare it back when he re-drafts.

The problem for a new writer is recognising which bits of your back-story are necessary for the reader to know. The answer will almost certainly be, a lot less than you think. Or, alternatively, a lot later than you think. If it is essential that your reader knows that Mr B's mother died in a fire when he was six and that is why he is emotionally difficult, then you don't have to describe or even mention that incident the first time that the reader meets Mr B. You already know that you don't need to tell us what Mr B looks like in every detail, and equally the details of his psychological make-up can be withheld until later, when the present-time story is underway. That way, you don't slow things down in the early stages and you can use withheld knowledge or flashback as a plot development later on. In the meantime, you *must* have a present-time plot that is interesting enough to stand on its own. If your plot is dependent on your back-story, on constant explanation of why characters do

certain things, then maybe you just don't have enough plot to be going on with and are filling in the gaps with background and padding – in which case, back to the drawing board.

WEEK 39

When I asked those following the newspaper column to tell me what aspect of writing caused them the most difficulty, it won't surprise you to learn that plot came out as number one. The number two difficulty did surprise me though. It was dialogue.

Why should writing dialogue be particularly problematic? We are surrounded by it so much in our daily lives you would think it possible to pick up the nuances of it by osmosis — and that rendering those nuances on the page is a matter of simple mimicry. I realised that because dialogue is one of the bits I find easiest — possibly because

I write drama as well as fiction – I hadn't really thought about the technical aspects of it quite as much as I should have done. I once interviewed the playwright David Edgar. Like me, he believed that much creative craft could be taught: dramatic structure in particular, how to play with an audience's expectations. One thing he thought instinctive, though, was a flare for dialogue, an ear for the details and habits of speech.

Dialogue within a novel is a very different matter from dialogue in any sort of drama where it has to bear the entire weight of the work in question. When you write dialogue within a piece of prose, you have all sorts of props available. You can break it up with action or description or interior thought. You can – if you must – add a descriptive verb or adverb to express how the dialogue is being said, although these should be used very sparingly. (Often, you don't even need 'she said' or 'he replied'.) If you haven't written much dialogue before, a useful exercise is to go to a café or other public place and take one of those discreet tape recorders. Sit next to two or more people who are having a conversation and record just a couple of minutes of it. When you get home, transcribe those couple of minutes precisely, including repetitions, pauses, coughs and splutters. You will see straightaway how infrequently real speech comes in full sentences, how little it makes grammatical sense even when the meaning is clear. People change subject mid-thought or leave thoughts half finished. They interrupt each other or themselves. They make all sorts of

assumptions based on their knowledge of the person they are talking to, which alters the way they speak. Imagine you fell down the stairs this morning. Imagine how you would describe that incident to a workmate over a casual cup of coffee. Now imagine describing the same incident to your elderly, infirm aunt. Your entire vocabulary would be different.

When you have transcribed those two minutes of conversation, there is something else you should notice apart from how fractured real speech can be. Notice how much you can surmise about a person from speech alone. By simply studying the language those people use, you will find yourself making all sorts of informed guesses about who they are and their relationship to each other. In the same way, dialogue within a novel can reveal a huge amount about the characters who are speaking without you the author having to signpost such significance to your reader.

EXERCISE 20

Write six lines of dialogue – no more than six. Write them from the point of view of two people talking to each other and give them three lines each. The people concerned are discussing the refurbishment of the local library. Somehow, within that discussion, I want you to communicate that they hate each other, although they never say so outright. Communicate to your reader that these two people dislike each other intensely by the use of dialogue alone, even though that dialogue is about something else entirely.

As with all these exercises, the trick is to take what you learn from them and work out how or if it might be applicable to your own novel. Once you have written the lines of dialogue above, then chose a passage of dialogue from your own book and think about how the characters speaking really feel about each other and how that can be communicated – using their words to each other rather than telling us is always more effective. Showing not telling – that old chestnut is the most valuable chestnut on the tree.

WEEK 40

In Chapter 1, I quoted the author Susan Hill: 'Every time I am about to start a novel, I look at it, and it is like a mountain and I say to myself, oh no, this time you have gone too far.' I think that is probably my all-time favourite quote on the writing process – because it is particularly germane to my favourite aspect of writing technique and the one that seems to give nearly all writers most difficulty: plot. A plot *is* like a mountain in the sense that it is, well . . . big. People talk about getting 'an idea' for a novel but, as I have said before, a plot is not an idea any more than a mountain is a molehill: it's a whole collection of

ideas, many in conflict with each other. Put another way, I don't think it is possible to 'think of a plot'. A plot in its entirety will only come during the course of actually writing the book. Let's say you have written 20,000 words but you still feel it is all over the place. You like bits of it and have a vague idea where it's going but as a whole . . . One morning, when you least expect it, when you are sitting there slogging away at some minor aspect – suddenly, it will come, a revelation about what your book is really about, and there you will find your plot.

There is no fairy dust I can sprinkle that will make it come because it will only come when you are writing. There are, however, certain tricks you can employ that will help the process along, and here we return to some points I have already made in previous chapters. Forgive me if this seems patronising, but talking about writing is often the art of discussing the obvious. A plot is about things happening. It is about change, drama, conflict. If, by now, you have a collection of pages in which you have some interesting characters and some good description and some nice prose but no plot, it will be because there is not enough conflict. To apply the Susan Hill quote instructively, a plot is a mountain of those things; *lots* of happenings, *lots* of change and *lots* of conflict. This doesn't mean you have to fill your novel with meteors from outer space or car chases – although quite frankly I can think of a few prize-winning books that would benefit from them. Change and conflict can come in small ways, from the most seemingly mundane or domestic settings:

a pregnancy, a person expecting a promotion who is sacked instead (or vice versa), a chance remark that makes a character realise their whole life is a lie. The point is not to be scared of chucking a grenade at your characters. Sometimes writing seems so fragile, like your first time on a bike, that the tendency is just to keep going in a straight line for fear of falling off, but developing an interesting plot is about taking risks. In *Enduring Love* by Ian McEwan, the main character decides he needs a gun to protect himself from a psychopathic stalker, an authorial decision that could have sent the novel off into straightforward thriller territory but leads instead to a brilliantly realistic and comic scene about the absurdity of getting hold of one. The gun gets used later and, as in all his novels, McEwan treads a fine line between drama and melodrama – and occasionally falls off – but it's possible to argue that his fearlessness when it comes to large and sometimes implausible plot developments is one of the things that makes McEwan such an interesting author, lifting him above his contemporaries who often seem to be writing pretty but rather dull little novels about rather dull little subjects. The same is true of Martin Amis, who gets a good kicking every time he takes on a large subject such as Stalinism, but I would rather read a flawed book about the tragedy of Russian history than one of those poised little numbers where a couple in north London have an elegant dinner party where all their fine guests sit around having finer thoughts and feelings – any day.

You may not want to give one of your characters a
gun but you could give them a vegetable knife or half a
brick and – crucially – a good reason to use it. (Self-
defence? To protect a loved one?) Try going back to the
body of material you have been developing during this
year and introduce a note of melodrama. It doesn't have
to be an offensive weapon but how about a burglary or
a road accident or a heart attack? The point is to try
doing something dramatic to one of your characters that
you haven't thought of doing to them up until now – a
surprise development that will come as a shock to your
readers as well as you.

WEEK 41

The sort of surprise developments I was talking about in the last chapter don't have to involve dramatic physical action – they can come through a simple revelation that one character makes to another. Dialogue is a great medium for springing surprises on your reader. Put another way, you might find it constructive to consider the questions of plot and dialogue in tandem. In what way does your dialogue advance your plot but also how can a plot development be fed into dialogue to give it depth and meaning? If you're not sure whether your dialogue has real significance, then look at it and ask

yourself, in what way does it move the novel forward? Is it adding depth to your characters, or scene-setting – or is it just marking time? What is the function of this exchange?

If you do allow a revelation or surprise development through dialogue, though, you have to be careful to keep it realistic. Make sure it doesn't become like one of those scenes at the end of *Scooby-Doo* when Velma steps forward and explains exactly how the villain did it. If in doubt, run round the block three times chanting to yourself, *less is more, less is more*. Write the longer version of a revelatory speech, and then pare it right back to the bone.

When I asked the column readers to write six lines of dialogue about the local library, the less-is-more rule was in engaging evidence.

'Taupe.'
'Beige.'
'Taupe.'
'Beige.'

This exchange, by a Ruth, was instructive as well as witty. Although the conversation extended in the next two lines, those first four told readers more than was immediately apparent. You can tell immediately that the people speaking are childish and argumentative, for instance – and familiar with each other. You don't have that sort of conversation with a stranger. The most interesting dialogue

makes the reader wonder about the true nature of the relationship between the characters involved, such as this example by Tom Rayfield:

> 'Great. They're doing up the library.'
> 'Waste of my council tax. Nobody reads books any more. You don't even have to read a book to get an A level.'
> 'I read books. I love books. You're a nutter.'
> 'Bet both your friends read books too.'
> 'You are an illiterate cow.'
> 'At least I'm not a bookworm, living off borrowed books.'

This passage gave me a strong image of a grown-up man, working class and self-educated, still living with his curmudgeonly mother in a Steptoe and Son-type relationship of mutual fondness and antagonism. I could even guess at what they looked like.

T. Stanley used repetition, 'Would you like any help, sir?', to demonstrate how deliberately annoying someone can be while the words they use are ostensibly polite. 'Stressless' had fun with the ways in which people can be subtly unpleasant to each other: 'Hi ya, I like your coat. Is that style back in fashion?'

Dialogue is deceptively easy to write sometimes — each line can bounce off the previous one — but there is a danger. Because it is so easy, it is also easy to write reams of the stuff and use it as padding. Luckily, it is also

easy to rewrite – just cut it down. Make it oblique. Trust your reader to guess at what your characters really mean in exactly the same way that we all have to guess at what people really mean in our daily lives.

Having pared down your dialogue, you can afford to break it up a bit, to add a bit of contextual colour. Constant repetition of 'he said' or 'she said' is unnecessary. It is usually obvious who is speaking. If it isn't, try adding a small, physical action.

'Look, I've told you.' Sarah reached for her stapler. 'I would love to help, you know that.' She pressed hard.

Try adopting a contradiction between the words your character is using and their actions. This sets up a pleasing dissonance and adds a note of realistic tension to an otherwise everyday exchange.

Introducing tension is also what I was talking about in the previous chapter when I urged you to chuck a grenade at your characters. The tension comes not from the unexpected event but from watching how the characters deal with the consequences of it – and here we come to the tricky bit of using drama and conflict in your writing. You have to follow through.

EXERCISE 21

Invent an event that will occur in your novel: the sort of things I was talking about last week — a heart attack, an accident, a truth unexpectedly revealed. What is the main consequence of this event? You can either write a paragraph of fiction in which this occurs, or you can summarise it in your own words. 'Paul receives a letter from his mother. He had always been told she died in a fire when he was four. Now he must track her down and find out what really happened.' Do it in whatever way you feel comfortable with, but just make sure you write down not only the event itself, but what will follow.

WEEK 42

Throughout this book I have been urging you, to the point of obsession, to add drama and conflict to your work, to have a plot in which something actually happens, but there is a risk involved – a particular disease that can afflict all sorts of writers, young and old – climaxitis: a rash of climaxes.

Diagnosing climaxitis is easier in some cases than others. When it comes to crime series on television, for instance, climaxitis is as obvious as the psoriasis on the face of the singing detective. You are hurtling towards the ad break at the end of episode one – time for somebody

to pull a gun. In novel-writing terms, climaxitis often takes more subtle forms. Ever had the sneaking suspicion, towards the end of a book, that the author has thrown in a dramatic event quite arbitrarily – usually a child dying in a tragic accident – a climax instead of an ending? There is nothing more frustrating than spending 80 per cent of a book waiting for the story to start, only to feel that when it finally does, it's all over.

This is a question of balance and positioning, and to fix this one it is necessary to return to a process we undertook earlier in the year. Get out the body of material you have for your novel – the bits of paper, the odd scenes written, the notes here and there. Spread this material out all over the floor again, just like we did a few weeks ago. By now, I hope you might have started to fill in a few of the gaps but I want you to look at that material in a way that is purely structural. It is not just a question of where your dramatic events or plot developments occur, but what the consequences of them are. Screenwriting guru Syd Field has a neat way of describing them. He calls them 'plot points' and his definition of a plot point is quite specific. It is not just a dramatic development in isolation, it is an event that, as he puts it, 'spins the action around' and sends it off in a completely different direction. It is a point from which there is no going back.

In film-making terms, plot points are easy to spot. The first usually comes around a quarter of the way in, sometimes earlier. In Anthony Minghella's film *Truly Madly*

Deeply, we spend the opening fifteen minutes or so watching Juliet Stevenson grieving for her dead boyfriend and pass some time with her while her character and situation are established. She talks to friends, argues with her sister, cries all over her therapist. It seems to be a straightforwardly realistic film about bereavement.

Then, the ghost of said boyfriend, in the shape of Alan Rickman, shows up in her sitting room, large as life, real and physical. That's not just a dramatic incident, it's one of Syd's 'plot points'. After that happens, the story has changed irrevocably – we are watching a completely different film from the one we thought we were watching.

Similarly, in a novel, it is not enough to take a mundane tale about a man who is bored with his job and his family, throw in an unexpected death and a car crash only to reveal that at the end of the novel the man is still bored with his job and his family but his grannie's popped it and his ankle is in plaster. Any dramatic events you introduce must somehow change or impact upon your main character, and lead inexorably to the next development. This is why it feels like cheating if you throw in an arbitrary event at the end of the book just to bring things to a conclusion. At the beginning, the reader will accept an arbitrary event – even the most unlikely of coincidences – because that is the premise upon which your work stands. But concluding with a coincidence for the sake of it will feel as though you had no idea how else to wrap things up.

When you have the material for your novel spread out before you, ask yourself this: Are the dramatic events and developments that occur spread evenly throughout the book and are they linked and consequential? You could do a lot worse than temporarily adopt Syd Field's screenwriting model and think about whether you have a 'plot point' one quarter, one half and three-quarters of the way through. You may well find this dissolving as you work your way through the book later and I'm not suggesting for a minute that you have to stick to this model or any other but, if you look at your body of material and realise that actually nothing much happens in the first half apart from the characters being introduced, then you have a structural problem that needs fixing sooner rather than later.

WEEK 43

The last exercise I set was difficult, so well done if you attempted it. It is always difficult to summarise the events in a book. That's why the synopses so beloved by agents and publishers sometimes seem harder to write than the novel itself. Any idea or plot development sounds idiotic when summarised. When you are writing a synopsis of any sort, you are stripped of the props that full-length prose offers, the opportunity to demonstrate your writing skills through description or metaphorical language or dialogue. Your plot stands naked before the reader, knobbly knees on show for all to see.

That said, it was interesting to see how many of the writers following the column were still prepared to have a crack at this difficult thing – perhaps aware that they may well have to write a synopsis to sell their work at some stage, and describing a dramatic event and its consequences was a good starting point. Several themes cropped up again and again. Harm coming to children was common, such as Steve1's idea about a father who foresees his son's death and does all he can to stop it while, Oedipus-like, heading relentlessly towards his fate. Allyson reversed event and consequences in her idea, a description of a mother saying to policemen and reporters, 'I was only gone a few minutes, I just wanted to put the washing out and make a quick cup of tea.' The summary then worked backwards in time until we were told, 'She smoothed a soft blond lock from her baby's brow and watched him passionately as he slept.' Lorraine's idea featured a woman who borrows a well-thumbed novel from a hotel reception desk while on holiday in Tenerife. The book contains details only she knows about a tragedy in her past. Who is the mystery author and how can she track him down?

If you are having trouble with a synopsis or any sort of summary, then try posing yourself a series of questions about your book. If it still sounds dull, then maybe you need a bit more drama. A lively synopsis, like an interesting novel, offers the reader something beyond their known territory. The plots that stood out among the ones I was sent often involved foreign climes. 'Mac' had

an idea for a story about a Russian Army conscript injured in a terrorist bomb on the Moscow underground and his subsequent plan for revenge. I also enjoyed Julie's premise about a gated community in an unnamed 'underdeveloped country', where the wives sit by the swimming pools while their husbands are off on their lucrative contracts. They are happy with their cross-stitch and their charity committees but a new arrival, Meg, is about to upset their comfortable lives. This scenario was a reminder that dramatic events in a book do not have to take the form of car crashes or kidnappings – a stranger coming into the midst of a settled group can be highly dramatic as well.

Most of the replies to this exercise took the form of beginnings rather than developments that occur 'mid-book', which brought home to me just what a difficult thing that exercise was. Even if you have a strong, dramatic premise in mind, it is sometimes still hard to work out its placing in your book. If you are finding that the case, then there is no substitute for stepping back and trying to see the thing as a whole. Spread your material out on the floor, as we discussed before, or pin chapter summaries on the wall or whatever method grabs you. Think of it as being like using binoculars. Delightful as it is to focus on detail, there are times when you need to observe the entire landscape. You can then focus in again with the enriched understanding achieved by regarding the general view.

When I asked the column readers to tell me their

biggest technical problem, 'jeffgwatts' inquired about how to handle large-scale action scenes: 'Every time I try writing these I lose my nerve and go off and do a nice small scene instead.' Having written a novel set during the Second World War, I could sympathise with that one. One solution is to keep it simple, to describe physical action in plain, unadorned prose that lets your reader fill in the picture with their imagination – you can always add embellishment on your rewrite if you feel it isn't evocative enough. Another approach is to concentrate on one particular detail or sensation, what a character can hear, or the pain in their arm. Any of you who have been in a physically traumatic incident will remember that it is the details that stick. But it may be that if you are having trouble describing a large-scale event, the problem is not one of detail but of perspective. However grand a happening is, to the individuals caught up in it, it is still an individual event. If you were describing an earthquake in your novel, you would be unlikely to say, 'As Sara lifted her washing from the tub, a 5.5 Richter scale quake struck the village and the water in her tub began to slop wildly from side to side . . .' You would say, 'As Sara lifted her washing from the tub, the water in it began to slop wildly from side to side . . .' Your reader may be bewildered temporarily as to what is going on but Sara herself is bewildered too. Even if she realises it is an earthquake, she won't know it is 5.5 on the Richter scale while it is happening to her, unless she is a scientist and she wants to make an educated guess as an interior

thought. (Even under those circumstances, I can't help thinking your average expert would still dive for cover.)

Whatever form your plot summaries take, when you come to flesh them out in the novel itself, you must know from whose point of view these events occur. Hence we move on to narrative viewpoint: who is telling your story?

EXERCISE 22

Take a passage from your novel, and change the point of view: if it is first person, change it to third, and vice versa. You don't have to use a dramatic event in your book, although that might prove the most instructive way to experiment with this. Either way, try to make it a longish passage, a couple of thousand words at least. When you have the two versions, put them both back in your folder or drawer, as we have done with previous exercises, then get them out a few days later and read both, one after the other. Which do you prefer, and why?

WEEK 44

Who is telling your story? I'll give you a clue. It isn't you. You are the author of your work, but unless you are writing pure memoir, you are not the narrator. The narrator is a character within your novel with his or her own angle on things. The reader sees the action of the book through that narrator's eyes, which means they get a skewed vision of what is going on — a narrator always has an axe to grind.

There are three basic types of narrative viewpoint: first person, third person subjective and third person omniscient. First person, the 'I' voice, is often the style

of choice for new writers and it does have several advantages. It is easier to write internal thoughts or reflections and often easier to get a narrative tone using particular words or turns of phrase. It's an act of ventriloquism. The drawbacks of using the first person are: it is hard to shift point of view, unless you have your narrator reading someone else's letters or diaries, which makes it difficult to introduce variety into your book; and the very ease of writing in the first person can be a hazard. If you hit your stride with your narrator's voice, you can end up writing page after page of him or her wittering on about himself or herself, which is every bit as dull for the reader as listening to a pub bore.

Third person subjective narratives are often quite close in tone to the first person. You say 'he' or 'she' instead of 'I' but you still focus through the eyes of that individual. It is easier to use multiple narrators and chop and change between different points of view, but you have to be careful not to do it too frequently or your reader will get irritated. You may know your characters intimately but your reader is not so familiar. Each time you change point of view, you need to re-engage the reader in whoever is speaking, when they may have already emotionally invested in another character.

The third person omniscient narrator is a whole different bunch of bananas. Nineteenth-century novels used them a lot – those voices that told you the story, God-like from on high, knowing everything. Using an omniscient narrator gives you the advantage of moving

seamlessly from one point of view to another. 'And now, let us return to Maurice, who has been waiting for Helena for two hours, unaware that while he waits . . .' but, as you can see, the tone of an omniscient narrator is often somewhat arch. Quite frankly, unless you are writing self-conscious pastiche, you are better off sticking to first person or third person subjective. Third person subjective with multiple points of view can often achieve as much as an omniscient narrator anyway, and it won't sound as though you are writing with a broom handle up your backside.

Narrative viewpoint is a complex issue and the only way to really get a handle on it is to experiment, to write whole sections of your book in first person, then third, and to sit back and appreciate the different textures of the two narrative styles. Many books have more than one narrator, of course, and you can have great fun with different points of view, showing the same incident through different eyes and playing with the reader's sympathies. My last book was narrated alternately by two women who hated each other – the idea being that when you read one woman's version of events, you were on her side and when you read the other's, you changed your mind. I can't say whether it was successful or not from a reader's point of view but I certainly had a lot of fun with it. Andrea Levy's *Small Island* has four narrators who successfully coalesce. Some novels have multiple narrators who never even meet. Rachel Seiffert's *The Dark Room*, for instance, consists of three entirely separate

stories, with separate narrators, linked only thematically. The problem with using multiple narrators is that there is always a risk your reader will prefer one to another. I would also advise against mixing the first and the third person in the same book. Many authors do – *mea culpa*, novels number two and three – but I now tend to regard it as a sign of insecurity, suspecting that the author couldn't cope with the limitations of one style or another and so decided to mix them up, hoping it would look postmodern. There has to be a cast-iron reason for that kind of stuff otherwise you won't get away with it. Readers aren't fools.

Experimenting with your own work is the only real means to feel your way around this issue but it is also worth experimenting with other people's work too – they will never know. Pick a favourite novel, preferably a contemporary one, and try rewriting the first page using a different point of view or narrative perspective. It will give you an insight into why the author chose the perspective they did. You might think your version better, of course, but if you ever meet them, I suggest you don't let on.

WEEK 45

Here are two characters in the same story, written by a message-board contributor called Kristin. The first is a teenager, Sadie. 'I'd say I was just vulnerable. Yes I've had my probs. I've been into drugs, binge drinking and sex but then who hasn't?' Here are the same lines from the point of view of Sadie's mum. 'She's so vulnerable. But she's off the drugs and drink, more or less, and making progress in her choice of "mates".'

One of the advantages of writing from different viewpoints is the possibility of playing games with voice. Both Sadie and her mum have their own language as well

as points of view. When Sadie says 'who hasn't?', she is justifying her own behaviour in terms of the ways others around her also behave. Her mother has a quite different perspective on her daughter's 'mates'. And look at the word 'vulnerable'. It is used in both passages but has quite a different tone in each.

Some message-board contributors stuck to the letter of the exercise more closely but demonstrated the same point. 'Jan h' wrote of a hilarious encounter between a young man called Nigel and a rather large older lady: 'She was locked briefly in a testing struggle with her corset but then it was off and Mrs Pugh flowed free . . . she advanced purposefully . . . Nigel was engulfed, suffocating fast.' Rewritten in the first person, the piece had a different feel: 'Once the corset was off there was no stopping her . . . being a St John Ambulance volunteer, you'd think she'd have noticed me going blue but she had other things on her mind.' I preferred the first version because the description of Mrs Pugh flowing free was irresistible – but one option would be to combine the two, to have the high camp of the third-person narrative coming out of Nigel's mouth. Another writer, the irrepressible DtheR, had some words of wisdom on the topic: 'The point emerging from the exercise so far seems to be that each perspective seems to exclude facets of an incomplete yet sustainable story. In the first person, the loss is obvious and in the third, the writer's skill is in omitting as much as possible while leaving a comprehensible, interesting and entertaining narrative.' Resign

yourself to the fact that whichever narrative style you choose, you lose something. Italo Calvino wrote a whole novel, *If on a Winter's Night a Traveller,* in the second person. It's opening sentence is, 'You are about to start reading Italo Calvino's new novel *If on a Winter's Night a Traveller . . .'* As an exercise in literary games-playing, it is great fun, although whether it is anything more than that is open to debate.

If you are getting on well experimenting with your own work, you could try a further exercise, which is to take a passage and experiment with the use of tense. Using the present tense can have real immediacy – Ronan Bennett used it to superb effect in *The Catastrophist* – but that may not be appropriate if you are writing a slower or more elegiac tale. Again, the only real way to get a grip on the difference is to try both past and present tense, which gives you a clear understanding of why you make certain creative choices and what effect those choices have on your reader.

The subject of narrative style is so complex it is worthy of a whole year's study on its own. As a general rule, I don't think it's something you should get too hung up on if you are still in the early stages – just do whatever feels instinctively right for now. But when it comes to rewriting, injecting life into your story and your characters, experimenting with first and third person and past and present tense may well open your work up and give you a new perspective on what you are trying to do.

EXERCISE 23

Rewriting is our next topic. To that end, I want you to go back to your work again, and choose your favourite bits. Yes, it is time to pat yourself on your back. Instead of endlessly rereading and trying to work out what is wrong with your work, I want you to flick through it and find the bits that you really love. Dwell upon them. Read them out loud. Give yourself a little tick in the margin, if you like. Think about what you do well.

WEEK 46

'If there is anything in your own work you think particularly fine,' said Ernest Hemingway, 'strike it out!' Well, that explains *Across the River and into the Trees*.

Few of you aspire to be as plain and brutalist as Hemingway, I suspect, but his dictum is still worth tucking in a corner of your brain, not to be followed slavishly but as an antidote to that great curse of the tyro novelist: over-writing. How do you know if you are over-writing? Well, an excess of adverbs and adjectives is always a clue – repetition under the guise of emphasis is another and extended metaphors should be

rationed tightly enough to require a government permit to use one.

That said, there comes a point in every novel where you just don't know any more. You've been immersed in it for months, possibly years. You've lost sight of the original excitement and impetus behind the book and are plagued with self-doubt — yet at the same time, you know there is *something* there and are not ready to give up on it.

This is the point at which you should be considering getting some feedback. As a general rule, I would advise against getting it from your nearest and dearest. You will be unduly wounded by their criticism and suspicious of their praise. Asking your significant other if they like your work is no more likely to produce an honest answer than asking, have I put on weight recently? This is where joining a writing community of some sort comes in. Such a community formed on the 'Novel in a Year' website, albeit one responding briefly to very short sections of work. There are many other online writing groups around if you like the anonymity they offer, although when someone is criticising my work, I like to see the whites of their eyes. Creative writing courses and book groups are also good places to find like-minded souls. Often, through such contacts, you can find someone who understands what you are trying to do — which is not the same thing as someone who is uncritical of the way you do it. There is a time and a place for emotional support but that its not what we are talking about here.

We are talking about discovering another writer who is prepared to say, 'I really like the opening paragraph but I thought it went a bit wrong after that *because* . . .' and, crucially, is prepared to back up what he or she is saying with specifics. 'I just didn't like him' is not a helpful comment when you are discussing your main character. 'I lost sympathy with him, in the scene where he tells his brother the truth because I thought he was too brutal. Maybe you should rewrite it making his motivation clearer.' That is useful advice – which you can then choose to take on board or discard. Similarly, at the level of prose style, some well-meaning person might say, 'It's a bit boring', but a helpful critic would say, 'You have three paragraphs of description here before you tell us who is talking, maybe you should consider starting the conversation first and weaving the description in instead of having it all in one chunk.'

I have several very fruitful relationships with other writers with whom I feel able to swap work. If we are discussing novel they pay for dinner, and vice versa. If you can find another novelist who is working at a similar level to yourself, with similar interests, who is frank and unafraid of frankness from you, then bind them to you with hoops of steel.

But even with a trusted ally, there comes a point when you have to stick to your guns and say, this person whom I really respect doesn't like this bit, but I do and it's staying in. How do you know when to do that? Well, for a start, a lot of the criticism you receive will be stuff

233

you knew already, you were just hoping nobody else would notice. Sometimes, you will bristle at a certain comment not because it is untrue but because the consequences of righting that particular defect are too daunting to contemplate. Accurate criticism is the most painful of all.

On other occasions, you will have a gut feeling that the person reading your work just doesn't 'get' it, or wants you to write a different novel entirely. Frequently, the only way to work out if criticism is useful is to nod sagely, then file it in a drawer. When the wounds have healed over and your ego is no longer under immediate threat, then you will be able to assess its true worth.

WEEK 47

If you are new to writing or are exposing your work to others for the first time, you will find adverse comment incredibly painful. Get used to it. A writer's life is full of knocks. At least if others spot the flaws in your work early on, you will have a chance to correct them before they scupper your chances of getting into print. If you have a good idea for a book, then don't squander it by sending out an early draft just because you are exhausted.

That said, I was impressed by the standard of the writing that came in in 2006 when I asked writers to

choose their favourite bits of their own work. To their collective credit, the writers concerned did not pick the most flowery or ornate sections, as I suspected they might. There was relatively little over-writing and those who posted on the website responded well to comments from others. Many posted what were clearly opening lines, such as this from Vivie: 'I don't know what you can do about lust once it grabs hold of you . . . Just before I met him I had been thinking how much I missed the smell of a man . . . that strong aroma of tobacco, scented soap, sweat, metal and mineral oil that only a few men exude.' Or this, from Tallulah Long: 'A week after my daughter died, I found myself on Brighton pier, staring into the clammy face of a palm-reader.' But with good openers like those, it was difficult to offer meaningful criticism, other than asking to see the rest of it. Criticism was more appropriate when it came to the longer passages, such as this one from P. J. Lazar: 'One night, in autumn in the moonlight under the stars, I went to the wood . . .' Several praised the lyricism that followed but N. Mott asked, pertinently, 'not sure how this would work in a novel, unless it was used in the prologue'. It is certainly true that in a prologue you can set a scene or pose a question in a way that may not have immediate relevance to the main plot – although it should always earn its keep by the end of the book.

The point of the last exercise was to urge you to become your own critic – something you all did automatically when you selected what you regarded as your

best bits. Even though you were looking for what was good in your work, you were criticising the rest of it by default. *Why* did you think that particular paragraph was a good example of your prose style? What can you do to bring the rest of your work up to that standard? Sometimes, we like a section of our own work because of what happens within an individual scene – a moment of catharsis for a favourite character, perhaps. Often we know it is more than that: the passage in question is well-written but also emotionally authentic. The corollary of this is that there are other moments in our work when we know in our black little hearts that it is dishonest, done for effect, because we were aiming to impress. Develop and then trust your own inner radar on this issue. Sooner or later, you will want to start showing your work to others and when you do, the chances are you will choose the 'best bits' to begin with. This is only natural, but it does mean that you have to be careful of your own reaction when a critic does not necessarily recognise them as such.

When it comes to listening to criticism from others, there is one basic rule: resist the temptation to defend yourself. If you argue back, you will stop listening and maybe miss the one small but very useful point the other person might be making. There's a Romany rhyme that I quoted at the beginning of *Stone Cradle*. 'Whatever igno-rance men may show/From none disdainful turn/For every one doth something know/Which you have yet to learn.' Bear that in mind next time the irritating geezer in

your creative-writing group is rabbiting on and on about how he doesn't think your main character really would do that because he wouldn't, would he . . .? The old geezer may be incredibly ignorant and annoying, but just before he shuts up, he might be the only person who points out a word repetition or a split infinitive. Never dismiss anyone's opinion wholesale.

As we are approaching the final chapters of this book, I want you to look at the body of material you have built up during the course of reading it and start to make some hard decisions. Now is the time to think about endings. One of my column readers, Julie, commented, 'Happy-ever-after endings seem so crass. I want to keep it real but can I satisfy the reader without necessarily having a resounding resolution of conflict?' It was a good point to raise. Hands up all those who have been disappointed by the ending to a book they have otherwise really enjoyed?

EXERCISE 24

Write a short paragraph describing the end of your novel. If you don't know it yet, then make it up on the spot. 'At the end of my novel, the Martians are victorious and the history of planet Earth enters a new dark age.' Or, 'At the end of my novel, Maria decides to leave Costa Rica but it is left ambiguous as to whether she will actually go through with it.' It sounds deceptively simple but is – of course – much harder than it seems. Don't be fancy about it – no one is going to see it but you – just concentrate on how you are going to wrap up your plot.

WEEK 48

Did I sound a little peremptory at the end of the last chapter? How did you feel about me demanding you decide how your novel ends, just like that? A little indignant, perhaps?

Is it really that simple? Can you just 'decide', almost on the spot, how your book is going to end? Sometimes, sometimes not – some developments in a book really do defy description until you have written them out thoroughly. Sometimes, though, you have to be bold and decisive almost as a way of tricking yourself into writing. You can procrastinate endlessly while you make difficult

creative decisions but there comes a point where you have to abandon all caution to get the thing moving forward. If you are stuck in the middle of a book, maybe a bit bogged down or having some sort of hiatus, then be bold, leap forward and write the final scene, even if you don't know how you are going to get there. What have you got to lose?

Even if you are nowhere near the ending in terms of a word count, it will help the plotting process immeasurably if you have an end point in view. I always know my ending right from the beginning. The first and last page of a novel are easy – it's the several hundred pages in between that cause me difficulties. Deciding upon an ending and writing it up will teach you a lot about your book – including, perhaps, that you don't want it to end that way at all. I once read somewhere that crime writer Ruth Rendell waits until she's nearly at the end of her first draft, then changes the identity of the killer. I've never met Rendell but if I ever do I will demand to know how this works on a practical level. Presumably it means that when she rewrites, she has to work in extra clues to the identity of the new killer, while leaving her original suspect in place as a red herring. How does it affect her, to be working her way through a book knowing that the person she thinks of as having committed the murder hasn't really done it? Doesn't it make it harder for her to write convincingly? The creative ramifications of this method are endless, which is why I suspect this story might be apocryphal.

Even if the events at the end of your novel remain the same, when you come to rewrite your conclusion in the light of what has gone before, you might find the tone alters. This is particularly true if you have planned the much-maligned 'happy ending', whatever that phrase means. When you have lived with your main characters for several hundred pages and made them feel real to yourself and your reader, you may well find that introducing a hint of doubt seems more realistic and convincing. You don't have to be bleak, but you can provide a resolution that includes a note of ambiguity. It is very, very hard to pull off a completely 'happy ending' without seeming trite – which is not to say you shouldn't attempt it if it feels true.

The issue of how real your characters feel to yourself and therefore your reader is pertinent to a good many subjects other than endings. The answer to many of the difficulties authors encounter during the course of writing a novel often lies in character development – it is always a good place to return to when you are stuck. Sometimes it feels hard to find your way 'back' to your characters when you are mired in the complexities of plot. When I asked those who followed the column to tell me their most pressing writing problem, an author called Kylie raised the difficulty of making characters distinct from each other – a common problem in the early stages of writing when it is easy to feel as though your entire novel is populated by people who are no more than different versions of yourself. Another author called

Astra replied, 'ALL my characters use exactly the same vocabulary until I revise to give them all a bit of individuality.' A key word here is 'revise'. Much of your character development may well come in the rewrite. When you get to that point, you might find an arbitrary change is needed to make a character feel distinct: change them from black to white or vice versa; change their nationality; give them a Swedish grandmother and go off and research Sweden; give them a disability; reveal they were adopted; give them a hobby. Did you know some types of turtle need feeding with dog food? Maybe one of your characters keeps turtles. I know quite a few authors who are snooty about research, believing that it applies solely to historical novels when you need to know what modes of speech people used in the sixteenth century or what sort of gun was fired in the Crimean War. I use the term 'research' much more broadly, meaning a recognition of the importance of detail, discovering the psychology behind your characters as well as facts about them, making them feel as though they are people of depth rather than cardboard cut-outs, ciphers. The last time a fellow author, an older man, made some scathing remark about how he never did any research, I had to bite my lip to prevent myself from saying, 'Yeah, that's why your characters are so two-dimensional.' He believed that because his work was contemporary, mass market genre fiction, then 'research' was somehow unnecessary. I couldn't disagree more. It can take days and days of thinking and planning and experimenting to

produce the one small paragraph that brings a character to life.

If you are prepared to put the hours in during the course of writing a book, you may well find that when it comes to it, your conclusion almost writes itself. If your ending is causing you difficulty, then the foundations you have laid for it may be at fault. Go back and do some more 'research' into your characters, in the broadest sense of the word.

WEEK 49

What are the essential elements that give the ending of a novel poignancy and depth? It is more than just the tying up of loose ends. It is atmosphere, a sense of mood, the feeling that what happens forms a fitting conclusion, which is not necessarily the same thing as a tidy resolution. An interesting example is Julie Myerson's *Something Might Happen*, a novel that opens with a brutal murder in a seaside town. Throughout the book, we are led to believe that the identity of the killer will be revealed, although it is quickly apparent that this is not a book about the crime itself so much as the effect of grief

upon a small community. As it turns out, we never find out who did it. Some readers might feel it is cheating to offer us a corpse on page one but no murderer at the denouement. I thought Myerson got away with it because although we never find out who the killer is, we are offered another highly dramatic and unexpected development, which, for me, took the place of the expected revelation. She also writes well – good move if you are trying to get away with something – but the main reason she pulled it off was because, although I wanted to know who the killer was, I realised at the end of the book that I had suspected all along I might not be told. The nature of the novel was brutal, psychological and – crucially – realistic, and, realistically, murders do go unresolved. This was a novel about aftermaths and open-endedness, about the things we do not know. If Myerson's book had been set in a country house and written in the style of Agatha Christie, it would have been much harder for her to pull off the trick of disappointing the reader's expectations, although I'm not saying it can't be done.

The most vital thing about the events that round off a book is that they should not feel tacked on or done for effect but a natural consequence of what has preceded. It is beside the point to worry about whether an ending should be happy or sad. What is most important is that it is congruent.

This doesn't rule out unpredictability. If there are questions to be answered in your book then several different possibilities could feel equally true. A website

contributor called Nicky had two possible endings, either of which sounded appropriate for the tone of her book.

> (1) Jo is trapped by her half sister Ana into recalling events buried in her subconscious that relate to the murder of her older sister Ellie. Jo had believed that Ellie's murder was carried out by a stalker, but it could emerge that Jo is mentally ill and has simply buried the fact that she murdered her sister in a jealous rage. Or (2) Half sister Ana takes on the mantle of murderess after several failed attempts to break into the tight relationship between Ellie and Jo. The examination of their relationships is the main topic of my book. Jo is writing her story in the present with flashbacks to the past so at this time it could go either way.

What seemed apparent was that this was the sort of novel in which either of those endings would be entirely plausible – or even the sort of novel where we might be offered two alternative truths. Perhaps the two versions could be offered to us from two different perspectives throughout, only for the real version of events to be revealed by the murder victim herself at the end. In that case, it probably doesn't matter that Nicky herself hasn't decided. The answer will no doubt come, and when it does, it will feel obvious.

Many of my readers expressed a desire to let matters take their course as far as endings were concerned. 'This is the first time that I've done that and it feels both scary

and liberating,' said Vaughan. 'I'm not sure if I'm kidding myself or really following the characters on their adventure.' I always prefer to set myself an ending to head towards – I feel more secure that way – but many, many writers enjoy the uncertainty, the feeling that their characters really are alive to them and have minds of their own. 'Yes, Vaughan, I think you have touched on something here. I am getting freaked out by this writing game; that old subconscious is a spooky whatsit,' said Vivie. It certainly is. If, like me, you prefer the teleological approach, there are times when it feels as though the characters are tapping the inside of your skull and demanding a change of direction, although often they are only telling you what you knew all along.

Speaking of spooky whatsits, I think it's a great mistake to assume that twists or revelations are somehow cheap, strictly for those writing thrills and chills. *Jane Eyre* anyone? *The Handmaid's Tale*? The entire oeuvre of Dickens or Le Carré? *The Spy Who Came in from the Cold* was intensely satisfying to me when I read it as a teenager because the moment I realised what was really going on was the exact point in the book when the main character realised it too, despite the fact that there had been many clues I could have picked up on before. Pull off something like that and your reader won't feel cheated, however large or surprising the revelation.

EXERCISE 25

As you are nearly at the end of this book, we are going to take a review of your 'year' – for the purposes of this exercise, I am working on the assumption that you are reading it over 52 weeks. This is another one of those list exercises, a bit like 'Allies and Enemies'.

Make a list of what you have done, and what you have learned. This might be a simple word count: 'I wrote 27,486 words' or, 'I started Chapters 1, 2 and 16 of my novel', or it may be something more nebulous like, 'I learned that my main character is from Estonia and now I have to go there.'

Then make a second list of what you have yet to learn. There's no point in being too negative here, in kicking yourself (or me). Be specific. 'I have learned that I have a lot of work to do on dialogue' or, 'I now know I have to go to the library every Tuesday or I will never get anything done.' Be down to earth and practical about what will be necessary in the future.

WEEK 50

If you are now at the stage of taking a general overview of your writing, you might find it useful to divide the issue into two: How have you progressed with your novel? And how have you progressed as a writer?

When I started the MA course in creative writing at the University of East Anglia, I thought I was there to spend a whole year writing. In fact, Malcolm Bradbury recognised and warned us early on that the year was about a lot more than getting words on the page. 'I would say about 50 per cent of the people who come on this course discover that they are not really writers,' he

confided in us, 'but the other 50 per cent discover that they are even more writers that they thought they were.'

For a while, it was touch and go which half I would fall into. I was one of the weakest writers in my year and they told me so. As a result, I spent quite a lot of time sobbing in the ladies' lavatory. Had anyone, including Malcolm, been asked to pick which students from that particular year might go on to become professional authors, I doubt very much that I would have been one of them.

I was stubborn, though, and after I had dried my eyes, I set about doing what I needed to do in the light of what I was learning about myself and my work. I had to junk nearly everything I had written up until then, including a complete novel and half of a new attempt. I had to abandon my many pretensions and think about writing clear prose instead of trying to show off. And I had to work out what it was I wanted to write about. At the end of that year, I realised that all I had produced of any worth was one 1600-word short story (a story that was eventually published in an anthology more than a decade later). When I considered this, I came close to despair. A whole year, for one very short short story? It is only now, twenty years on, that I can look back at that year and feel sure it was a year well spent. That short story was the first halfway decent short story I wrote. Without that year of sobbing in the lavatory and all those false starts to novels that were never completed, I could never have progressed to writing the work that made me a published novelist. Moreover, that year was just the beginning. Later, I wrote

another complete manuscript that still wasn't good enough and started several others. It was another seven years before I published my first book.

If you are serious about becoming a writer, then you have got yourself into a very long game and the early stages of it can be very, very slow. Comfort yourself, however, with the undeniable fact that however small your progress has been over the last year, it has been movement forward. If you have written 1600 decent words, you have achieved as much on paper as I did at UEA. You may feel you have not progressed very far with your novel but if you think of your progression as a writer, you may start to feel a bit more positive.

When it comes to the novel itself, if you have that loose body of material that we have discussed before – the half-written scenes, the research notes, the scribbled ideas – and if you have spread it all out and put it in chronological order and started to fill in the gaps, then the next phase you should probably embark on is what I call the 'donkey work' phase. I'll be honest – it's my least favourite bit, the bit where I set myself a word count for each day, then start at the beginning of the book and work my way through, grinding out the words, filling in those gaps. I find this so hard because it involves writing scenes that I don't really want to write – the ones I've been putting off. It also involves writing what I would call the linking or the 'time-passing' scenes, the ones that string together the various climaxes or catharses. In an otherwise negative review of my first book, a critic noted

what he called my 'flair for the epiphanic moment'. I realised, with some irritation, that he was right. I'm good at set pieces. I'm less good at the bits in between. Those bits are what get written in the 'donkey work' phase and they are the bits I need to do most work on when I rewrite.

There are still moments of joy in this phase – particularly when you realise that a scene you've been struggling with can just be axed. That is a truly joyful moment. Sometimes, though, you have to write the tricky scenes in the full knowledge that they are going to need an awful lot of work later. Occasionally, you have to leave a scene in note form and move on. I once delivered what was supposed to be a complete manuscript to my agent with a gap in Chapter 10 that read, 'big argument scene here'.

'Er, Louise, what's this?' he rang up and asked.

'Ah, sorry,' I replied. My eyes had carelessly skipped over that note to myself. I didn't want to write that argument.

The donkey-work phase is tough but it's satisfying too. It is the phase where you see the word count gradually mount up and realise you are working your way towards a complete first draft – and the satisfaction of that is worth many a sacrifice.

WEEK 51

When I asked my newspaper readers to review their writing year, it was cheering to realise just how hard many of them had worked. 'At the beginning of the year I'd been trying to write my novel for nearly three years,' wrote 'jeffgwatts'. 'I'm ending the year with just over seventy-six thousand words.' N. Mott said she had produced, 'Oh, LOADS! I am a quarter of the way through three novels; completed four short children's stories . . .' Word count prize went to an irrepressible character called Andrew A who laid claim to 360,000 words in the previous twelve months, 'and

that's without the thousands I've dumped'. A word count so prolific might be worrying without the observation: 'The more I write the more I realise that I have to improve beyond measure if my work is ever to be taken seriously.'

Like Andrew, most of my readers acknowledged that it was quality not quantity that counted. Many commented on the more nebulous ways of moving forward. Pamela Lake said, 'I'd had the idea for my novel for about seven years but I never seemed to know where to start and I hadn't got a clear idea of my heroine . . . I've really taken off. There's still a long way to go but at least now I've got the plot sorted out and I feel I know my two main characters very well.' AJS used the mountain-climbing analogy: 'I can see the summit from here and I can reach it.'

Many were kind enough to attribute what they had achieved to the column but, much as I would have liked to take credit, I knew – and they knew – that I had done no more than tease out what was there already. The problems some had with getting started seemed to stem from a common need, the desire for someone else to give them permission to go ahead with an activity that neither settles the bills nor involves paying attention to those we love. Tim G-M talked about the perpetual feeling that writing is a self-indulgent activity and hard to justify when set against the demands of jobs, spouses, children. 'It does feel selfish, doesn't it?' agreed Astra. 'Exactly what has held me back for years.'

There is a tricky balance to strike here. You have to be firm about finding time to write but, on the whole, I think that writers who use their work as an excuse to neglect or be vile to their spouses and children are generally people who would be neglectful or vile whether they were writers or not. Writing takes time but what you sacrifice to find that time doesn't have to be hurtful to those around you. My children don't care that I write when they are at school when I could be tidying the house, baking cakes or sewing name tags on their jumpers – as long as I'm there at the end of their day. The trick of time management is to be ruthlessly honest with yourself about those activities you regard as necessary, which really aren't. Hell will freeze over before I spend a morning folding clothes and putting them away in drawers when I need to be writing instead. If my family want their clothes, they know to look on the laundry rack.

EXERCISE 26

All of which leads us up to the final exercise. You've looked back, now look forward. I want you to go and buy a year planner, or find the page in your diary where next year is laid out month by month – or get a piece of blank paper and draw yourself a calendar if you plan your writing year from April to April or September to September. Either way, try to get the next writing year on to one sheet. Take a clear-eyed look at it. Some of it will be spoken for already: holidays, weddings, periods where you know you won't be able to get any writing done. But the empty bits . . . try to make an honest assessment about how much of next year is available for writing, and try to work out how you can either maximise that time or ring-fence it so that other activities will not encroach upon it. In doing this, you might find it helpful to look back again over the previous year and think about what impeded you – how can you avoid that happening again? When you have done that, look forward again and ask yourself this: What is the one thing I am going to do this coming year to help my writing?

WEEK 52

So, what next? I have no way of knowing how long your apprenticeship needs to last. Mine lasted roughly ten years, a decade during which I gradually (too gradually) improved as an author to the point where I sold a novel, got more journalism work and was finally able to make a living as a writer. I was lucky, in more ways than one. I was lucky to be a runner-up in a short-story competition and get an agent. I was lucky in encountering a radio producer (again, through an open competition) who understood the weird little plays I was writing at the time and was prepared to commission and direct them.

That luck would not have happened had I not worked extremely hard for that decade and therefore put myself in a position where I was able to take advantage of my bits of fortune when, eventually and intermittently, they dropped into my lap.

I have no idea if it will take you a decade to become a writer, or even if you have a decade to spare – but it might help to ask yourself this simple question: Why do I want to do it? If you want to be a full-time professional author paying your rent or mortgage and putting food on the table by your work, then you will almost certainly have to do lots of other sorts of writing as well as novels. I have published six books, counting this one, and had five plays produced on BBC radio, but I have a young family and live in one of the most expensive cities in the world. Unless I move to Orkney or hit lucky with a film deal or literary award, each of which is every bit as unlikely as the other, I will probably always need to do journalism and broadcasting in order to make ends meet.

Earning a living by my writing is important to me, probably because of the strict Protestant work ethic with which I was raised. The Protestant work ethic is useful in many fields but none more so than that of creativity. However many delusions I may have had about my budding literary genius when I began – and they were multitudinous and various – I never deluded myself that becoming a full-time writer was anything less than extremely hard work. Most full-time writers spend most of their lives in a room on their own. Is that what you want?

Put another way: What sort of writer are you? New writers often assume there are two sorts: the published and the unpublished, when, in fact, many fall into the grey area between. I know a significant number of novelists my age who have published two or three books that have then gone out of print. They now earn a living doing other sorts of writing, or secretarial or administrative work, or teaching. Technically, they are 'unpublished' but they rightly regard themselves as authors and are often hard at work on new books, in the hope of getting back into the system. Self-publishing and the Internet have further blurred the boundaries. If what you desire most is to see your work between covers, then self-publishing is a perfectly rational way of going about it, as long as you accept that you will not get review coverage or be stocked by the main book-stores and your chances of making your money back are slim. (Avoid, at all costs, the handful of vanity publishers out there who charge thousands of pounds for an unspec-ified number of copies of your work on the promise that you will make money and become famous. They are only after your cash. Never, ever, use a company that advertises, 'Authors Wanted'. Ask yourself why that company needs to advertise for authors when the vast majority of pub-lishers are forced to turn writers away in droves.) Equally, many people have found publishing their work on the Internet answers their need to have it available to a general public. Quite apart from needing to earn money, I'm too devoted to the book as a physical object – the apotheosis of which is, in my humble opinion, a battered paperback

with a broken spine. If you decide, for whatever reason, that you will probably not become a full-time, professional author, then you have a huge advantage over those who do want to become one. You are free to write whatever you choose.

For those who do want to be published convention-ally, there is a sobering thought to bear in mind and it applies to published authors as much as unpublished. It is always a shock to realise, after years of work on a book, that nobody rewards you for effort alone. Agents, publishers, critics and readers don't care how hard you've worked, they only care about the end result. If you have a good idea, and talent, then hard work is what makes your novel a reality but even when all three of those vital elements are in place, there are many, many reasons why it still might remain unpublished – or poorly paid for and ignored if it does make it into print. There are fashions in literature just like anything else and a good novel can be beautifully produced by a respectable and dedicated publisher who adores it – and still sink with-out trace. Happens all the time.

There are two ways to respond to this sobering real-ity. You can feel incredibly depressed by it, wonder whether it's worth it and contemplate throwing in the towel. Or you can decide that what matters is the love of writing, the complex joy of producing a work of fiction that is your own, with all its glorious flaws and eccen-tricities. If you take the second route, then you must do so in the full knowledge that publication, money and

acclaim are no more than the icing on the cake. 'Anything else is extra,' the novelist Pamela Johnson said to me once. 'We do it because we love doing it, and anything else that comes along is extra.'

Few of us are so pure of heart and mind as to be able to tell ourselves this wholeheartedly. Most of us nurse embarrassing little fantasies about the worldly acclaim we aspire to, even as the rational part of ourselves acknowledges the more realistic outcome of our ambitions. Over the years, I have come to manage this sort of twin-thinking without shame. I daydream all the time about the brilliant novel I will write one day and the hallelujah chorus with which it will be greeted – but if someone said to me, here's the crystal ball and it doesn't look pretty – your next book will be a critical and commercial disaster, your publisher will drop you like a hot brick and no one else will touch you with a bargepole – would I stop? No. I won't stop until I'm dead. I've stopped wondering why I won't stop. Perhaps there isn't any reason. I love doing it. If you love doing it too, then you will continue doing it regardless of encouragement from me or anyone else. Anything else is extra.